BETTER LANDSCAPE PHOTOGRAPHY

by John Hannavy
and
Duncan I. McEwan

HOVE~FOUNTAIN BOOKS

BETTER LANDSCAPE PHOTOGRAPHY

First Edition July 1988
By John Hannavy PhD FRPS FBIPP FMPA & Duncan I. McEwan
Produced for Hove~Fountain Books by
Icon Publications Limited using Apple Macintosh™ and
PageMaker 2.0™ computer typesetting and design
Series Editor Dennis Laney/Hove-Fountain Books
Edited and designed by David Kilpatrick
Printed in Great Britain by
Purnell Book Production Ltd

ISBN 0–86343–120–8

Published by HOVE FOUNTAIN BOOKS

45 The Broadway 34 Church Road
Tolworth Hove
Surrey KT6 7DW Sussex BN3 2GJ

UK Trade Distribution by
Fountain Press Ltd
45 The Broadway
Tolworth
Surrey KT6 7DW

CONTENTS

Section & Theme **Page**

1: Setting out... 8
 Equipment and approaches

2: Basic Techniques 19
 Understanding and using camera controls

3: Composition 28
 The essence of good landscape work

4: Light and Landscapes 38
 From dusk to dawn

5: Colour 45
 How to use colour effectively

6: Black and White 56
 Monochrome is part of the landscape tradition

7: The Changing Seasons 70
 Picture opportunities throughout the year

8: Rivers and Lakes 83
 The appeal of water

9: Sea and Shoreline 92
 Close-ups, islands and open sea

10: Natural History 103
 Landscapes through the macro lens

11: Figures and Buildings 113
 Adding human interest to scenic views

12: The Urban Landscape 123
 Cities and towns

13: The Professional View 131
 The freelance scenic photographer

INDEX 140
Locations of photographs 142

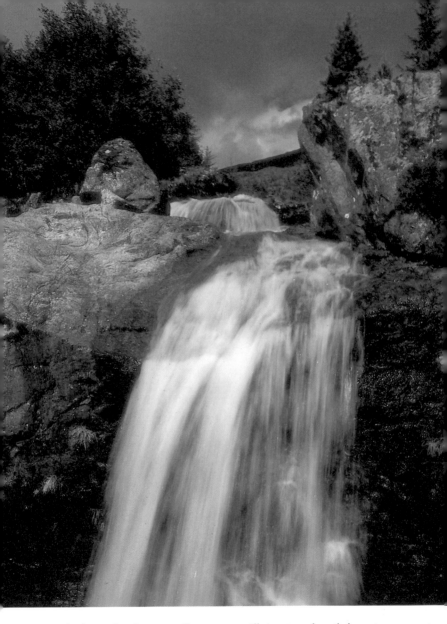

Rocks formed in forgotten fires, strong silhouettes of earth-born trees, brooding clouds in the air, and a rush of blurred water – four elements to form a landscape, through the lens of Duncan McEwan.

INTRODUCTION

WITH very few exceptions, the best landscape photographs you are likely to see are the result of careful planning and execution. What, then, makes the difference between a breathtaking view and a banal postcard snap?

The right viewpoint, the right lighting and the right equipment are all essential ingredients.

The most potentially dramatic of views becomes mundane and two-dimensional, irrespective of viewing position, if it is seen under flat direct lighting. It becomes insignificant if taken with the wrong lens, or meaningless and unimpressive if taken from the wrong camera position.

Good landscape photography doesn't just mean showing what a place looks like. The obviously visible aspects of the landscape itself play a minor role in our response to that landscape. It is the emotional response to actually being there which is most important to anyone who enjoys walking or just driving into the countryside.

A good landscape photograph should therefore convey something of what it actually felt like to be there, rather than just showing what it looked like. But no single image can ever sum up a scene perfectly for everyone. That may be the justification for the blandness of postcards – but it is also a challenge to the individual landscape photographer.

Photography is probably the most effective form of visual communication. It can be a way of telling a story – a paragraph of words contained within the borders of the image. We are constantly reminded of the landscape through television, books, magazines and advertisements. Good landscape photography is much more than just having the right bag of tricks in the right place at the right time. It is about using that equipment to say something about the world around you.

– John Hannavy

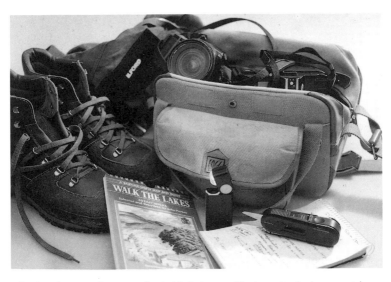

The landscape photographer's kit is just as likely to include an outdoor jacket, strong boots, detailed map, pocket torch, knife and notebook as it is to include cameras, film and lenses.

GOOD landscape photography is rarely achieved from the roadside or the car park. It is hardly ever a lucky accident. More often it is the result of careful planning, a lot of walking, and a considerable amount of time spent selecting the appropriate camera position to say what you want the picture to say. If you simply stop the car when a pleasing view presents itself, and take a picture through the window or from the roadside, it is likely that it will fail miserably as a picture.

Good landscape photography is about making clear conscious decisions about what to say, what to include, what to leave out, and where to say it from. More importantly, it is about being in the right place at the right time and with the right equipment. From time to time that lucky accident will occur – when all the conditions for good landscape photography come together – but when that happens the photographer can only take advantage of it by recognizing the opportunity.

To become proficient as a landscape photographer, it is necessary to learn enough about your camera to cope with many different conditions, not just those moments of perfect light on well-known views.

Planning

Landscape photography is mainly about style, so the first stage of planning any trip into the countryside should be to think what kind of picture you want to take. Very few people can be creative and expressive in all kinds of different ways and styles on the same day. Most of us have periods of intense photographic interest and enthusiasm, and periods of almost total inactivity.

A notebook taken everywhere – either the paper and pencil variety or a 35mm camera loaded with negative film – can become a resource book, where ideas are logged or sketched to be returned to later. In this way a list of locations, possible subject or ideas can be built up (even on days when the light and season are wrong) which can be developed later into carefully planned and executed pictures at the right time.

Light

The key to successful photography, irrespective of subject, is lighting. It follows that the most important insight for any photographer is an understanding of light – the way it moves and the way it affects the objects it illuminates. This will be dealt with in detail later in this book, but it is important to stress at this early stage that time of day, time of year, type of lighting and

colour of lighting are all essential ingredients of the successful picture, so planning to ensure that they are just the way you want them is vital.

If you see a potentially successful image, but the lighting is wrong, it is a relatively easy matter to decide at what time of day, month or year you should return with a camera. As photography is an all-the-year-round hobby, planning for pictures to be taken months ahead is not unreasonable.

Do bear in mind that as the seasons change, so do the problems of getting to any particular location and working there! The top of a mountain in winter is very different from the same location in the height of summer. A well-equipped landscape photographer will have a range of clothing and footwear suitable for all sorts of weather conditions – and if travelling any great distance from the car, will have a rucksack containing waterproof over-clothes which are both lightweight and strong enough to offer a reasonable amount of protection against the sudden weather changes for which hills and moors are so well known.

If you are not an experienced walker or climber, then a sound piece of advice is to limit your winter expeditions to tried and tested routes and well-populated places, while in the meantime getting some training and some

practice under the guidance of experts. Remember that photographers start off from a disadvantage; in addition to the normal survival kit carried by experienced walkers and climbers, we have a bagful of equipment!

A vital accessory

There is no such thing as a landscape photographer's outfit. Like any photographer's outfit, the landscape photographer's gadget bag should contain the right equipment for the job – no more, no less. That of course implies that the photographer knows what the job is, and knows therefore what constitutes the right equipment. Hence the requirement for 'recces' and planning. If you arrive at the location to take a particular picture, and another presents itself which would require additional equipment, then make notes and come back another day when the conditions for that second picture are right.

One item of equipment, however, is vital; a compass. Without it you can never accurately predict when – if ever – the sun is going to shine from exactly the right position to give you the lighting, shadows, textures and detail that you need. With a compass and a little seasonal knowledge such as the times of sunrise and sunset, and a general idea of how high in the

sky the sun will climb, you will be able to predict to within half an hour when the lighting is likely to be at its most effective.

With the compass, find north. Work out the angle of the sun, and based on an east-to-west movement of 15 degrees per hour, you can work backwards or forwards to get an accurate position for the sun at any time of day.

Cameras

Format and camera size and type present the landscape photographer with the greatest dilemma. At one end of the scale, 35mm is the lightest and most easily transported to out-of-the-way locations. On the other hand, the 5 x 4 in 'field' camera is the most versatile and allows the photographer the greatest control over image shape and sharpness, but is by far the largest if not the heaviest. It also requires training to use and each single exposure can cost as much as an entire 35mm film.

35mm, with the smallest negative or transparency image size, will not produce the image quality possible with larger film sizes, although with today's high quality emulsions that is less of a problem than it was a decade

Right: for the best results. John Hannavy uses 5 x 4" sheet film – but 35mm will do for most amateur landscape work

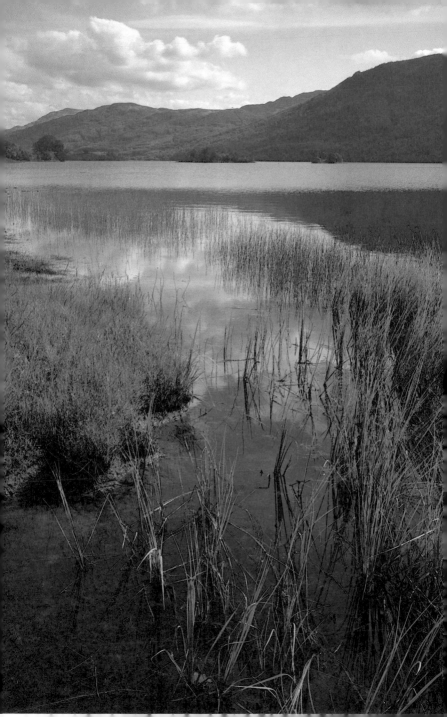

ago. In its favour, a 35mm system can include several additional lenses for the same weight as a basic rollfilm or sheet film camera and lens.

For some aspects of landscape work, the lack of apertures smaller than $f16$ on many lenses can be a disadvantage. Total control over sharpness might need a stop or two more – here, the latest autofocus systems often have advantages because some of their lenses stop down to $f32$. This kind of very small aperture, allowing great depth of field from foreground to distant view, is normally available on 'macro' and long tele zoom lenses.

Rollfilm cameras weigh up to four or five times their 35mm counterparts, and with one or two additional lenses can cause considerable problems both of weight and bulk. However, the very high quality optics of most rollfilm cameras, coupled with the availability of camera movements – either built-in or through the use of shift lenses – can greatly extend their usefulness to the landscape photographer.

Cameras such as the Rollei SL66 range and the Fujica GX680 with its front panel movements allow total control over image shape and sharpness without the requirement to stop down too far. The shift lenses available for Rollei, Bronica and Mamiya SLRs offer much the same controls. There is, however, a considerable

weight penalty.

View cameras – with 6 x 9cm, 5 x 4inc and even 10 x 8inc film formats – offer the ultimate in control but, with very few exceptions, also involve the greatest weight and bulk in the total system required. There are one or two lightweight 5 x 4 cameras, such as the American-made Calumet Hiker, which give all the advantages of large format at a weight not much greater than 35mm, but they are both expensive and difficult to obtain.

Additionally, of course, a 5 x 4 camera requires bulky and heavy dark slides to carry the film, and presents the additional problem of your having to carry either a large number of slides, or some means of loading and unloading these on location. On a mountainside in winter, with frozen hands, that is almost impossible.

Recently the introduction of a Polaroid-manufactured film holder and pre-loaded 5 x 4 transparency film in lightproof sheaths has made this aspect less troublesome, but the choice of film is very restricted.

Lenses

Lenses control how much of what you can see is included within the frame. They control the shape of the picture, and in conjunction with camera position, the perspective – the relative sizes of the objects within it. To be prepared for all eventualities, you

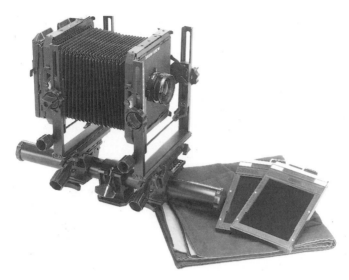

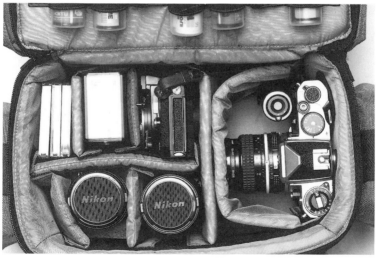

Landscape outfits in any format can be relatively light – top, a 5 x 4 camera in a highly portable form; bottom, a 35mm SLR with lenses. The overall weight is about the same for both outfits.

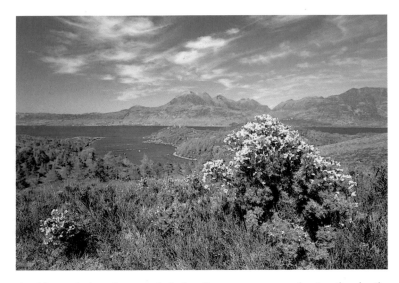

A wide-angle lens is a good choice if you want to emphasize the depth and sweep of a view. Duncan McEwan used a 17mm with a polarizing filter for this view of Torridon, Scotland.

would have to carry every available lens – and that is clearly impractical. For the well planned landscape expedition, particularly when returning to an already identified location for an already recognized picture, the selection of lenses can be determined from the reconnaissance visit. In that way the total equipment weight can be pared down to a minimum. For the unplanned or semi-planned expedition, limiting selection to the most obviously useful lenses is essential.

The most frequently used lens is a wide-angle or ultra-wide angle. It has several distinct advantages. Firstly, it exaggerates

the wide open spaces – and it is the sense of space which is the most significant single trigger in the landscape. Present viewers with apparently endless space, and they will respond positively.

Secondly, the perspective manipulation possible with such lenses, coupled with their usual ability to be stopped well down, allows both small foreground details and the sweeping expanse of the landscape itself to be recorded in sharp focus, with appropriate technique. That sharpness from close up to infinity is an important element in creating the three-dimensional quality which provokes such

strong reactions to good landscape pictures.

Equally important is the effect that extreme wide-angle lenses have on the photographic reproduction of skies. The exaggerated perspective has the effect of giving the sky much greater dominance in a picture, visually strengthening the sweeping patterns of clouds and effectively placing a 'roof' over the landscape.

For all these reasons, it is essential to be guided by what you can see through the camera viewfinder when selecting the best viewpoint/lens focal length/ aperture combination for a landscape photograph. What you see with the naked eye can be very different from what the camera will see. Only with a standard lens will the perspective and geometry of the landscape that you see be the same as that seen by the camera.

The combination of lens focal length and camera viewpoint controls the shape and the depth of the picture as well as the content. Long lenses appear to compress perspective and can therefore be effective in creating a claustrophobic effect if that is what you want to convey. Depth in the scene appears to become artificially compressed, distances apparently shortened. In reality they are not – all you are doing is enlarging a small central, distant part of what you can see – and if you look into the distance, you

will see that perspective is indeed compressed as objects move further away from you.

There are attendant depth of field problems with longer lenses, however and, as the most effective landscape photography is usually pin sharp, the use of tele lenses should normally be limited to those pictures and those conditions where the lens can be used well stopped down and on a firm tripod.

The tripod

Much of what has already been said about depth of field, stopping lenses well down, composing in the viewfinder and so on, presupposes that the camera is on a firm tripod – for without that, careful selection and maintenance of camera position is impossible. It is also worth bearing in mind that the problems of hand-holding a camera with an extremely short focal length lens are just as great as with a tele lens. While many photographers would not dream of trying to use a very long lens unsupported, they believe that they can handhold ultra-wides. With very wide angle lenses hand held there is a considerable drop in sharpness over the quality possible from the same camera/ lens/film combination tripod-mounted.

A tripod that is both firm and lightweight is essential, and difficult to get hold of. Most

tripods are either one or the other. A tripod should be chosen for a particular type of use. If you have three cameras – 35mm, rollfilm and 5 x 4 – then no single tripod is going to be effective. The size and robustness of a tripod suitable for a 5 x 4 view camera is very different from that needed for a modern lightweight 35mm. In landscape work, where weight is a prime consideration, there is no point in carrying a tripod bigger and heavier than the camera really needs.

For 35mm cameras, there is a wide choice of lightweight and sturdy tripods. As a general rule, the smaller the size the tripod folds down to, the less robust it is going to be. A leg section which is in five pieces is going to be less rigid than a three section leg when both are equally extended. It is also worth noting that a light camera on a light tripod will be just as easily moved by the wind as a heavy camera on a light tripod. Getting the right combination may take a bit of shopping around. For large rollfilm cameras, and for all view cameras, a heavy duty professional tripod is essential – and the weight of that will dictate how far you can walk carrying it.

The tripod will rarely need to be extended to its full height, and one with only three leg sections and an eye-level maximum height is all that is needed. Indeed, there are positive advantages. If foreground detail is being

included in the picture, the camera will not need to be very high off the ground, so the tripod need not be more than two or three feet high. A lightweight tripod only half-extended may be more use than a heavier one designed for greater leg extension. The basic rule is, of course, to try it. Don't buy a tripod on looks, try it out and buy it on performance alone.

Other accessories

As with all other occasions where a tripod is being used, a good cable release is also essential. Do not buy the metal sheathed variety – they are too rigid and can often transmit movement from the photographer to the camera – defeating the prime objective of using a tripod in the first place. Go for the (cheaper) old-fashioned cloth covered releases, and always use them with a 90-degree bend in them. That way no photographer-shake reaches the camera.

A lightweight, waterproof, sturdy bag to carry all the equipment is also essential. Choose one which has welded D-rings rather than simple bent metal ones to hold the straps to the bag – up in the hills you don't want the strap to come adrift or you may never manage to carry all the equipment back down again. Select a bag which can be fixed to a back harness so both hands are free for climbing.

A combined monopod and tripod from Susis.

Make sure it is waterproof to withstand sudden weather changes, and well padded.

Do not try to walk any great distance from the car with an aluminium box in your hand. By all means transport the bulk of the equipment in such a case, but transfer what you will need to a lightweight back pack before leaving the car park.

Filters

Most filters are for selling, not for using! The exceptions are few but vital. First and most important is a Haze or 1A, to cut down distant blue haze and to protect the lens. Keep a spare old 1A filter with you if you want to shoot landscapes in conditions where dust or grit may damage the lens, or use a gelatine or acetate one rather than glass or hard plastic which would be damaged permanently. Gels are cheap enough to throw away when they get scratched, yet offer good protection to the front element of the lens as well as doing their prime job of cutting out UV and haze. You can buy filter-mounts with no glass and cut these low-cost gelatin or acetate filters to fit.

A polarizing filter can be very useful – it exaggerates the contrast difference between sky and cloud on a clear day, turning the sky deep blue and greatly increasing the drama of the scene. It can also be very effective in cutting down glare off water, and creating very dramatic lake/river scenes. Polarizers have the effect of brightening foliage colours in most scenes, and some colour photographers use them all the time, even in dull weather, for this reason.

Third and last in the range of filters which are essential is a grey graduated filter where only the 'sky' half is coloured light grey – for darkening very bright skies and effectively reducing the overall image contrast. Many potentially excellent pictures are ruined by over-bright skies burning out to white or near white. The use of a carefully positioned 'grad' will eliminate that excess contrast and allow for much more control over the

relative weights of different areas within the picture.

A good grad, however, must be movable – it must be possible to position the actual grey/clear cut off exactly over the sky line. A Cokin-type square in a sliding holder is the best. Screw-in graduated filters are very limited in their use, as the transition is fixed across the middle of the image area, whereas the skyline will only rarely be positioned at that point.

Most of the several hundred other sorts of filters – brightly coloured grads, starbursts, streak and holographic effects or whatever – have only a very limited and infrequent use in good landscape photography. Any effect over-used becomes boring. The natural landscape is usually impressive enough to be in need of little help from brightly coloured bits of plastic.

Film

Film choice today is wider than it has ever been and quality is almost universally high. Selection of film for landscape photography, therefore, is much simpler than it once was. Today colour quality across all film makes is excellent, so which brand of film you choose is up to personal preference.

Choice is therefore likely to be based on grain size (very slow films) against usefulness (medium speed films). ISO speed 100

stock is most frequently used because it allows a good combination of fine image detail and sufficient speed to permit small apertures without over-long exposure times.

The most important governing factor, however, is your familiarity with the material concerned. If you know a film well and understand its potential and its drawbacks you are better able to exploit its strengths.

A useful additional piece of equipment is a Polaroid camera or attachment back for a rollfilm camera, and a pack of Polaroid colour print material. If you have walked miles to get a particular picture, a few pence extra on a sheet of Polaroid for a test shot is not an extravagance if it ensures that what you have composed through the finder is exactly what you wanted.

Polaroid tests on a camera like the Hasselblad or Mamiya 645 allow you to check composition, sharpness, colour, contrast and the effect your chosen shutter speed has on moving water, and so on. In those respects, it is a vital additional tool. For 35mm users, a separate Polaroid camera can record the scene as a notebook, with comments written on the back of the print. If you use ultra-wide lenses or long telephotos your Polaroid test will not be anything like your final pictures, but even so you may be alerted to possible problems or hidden potential in the scene.

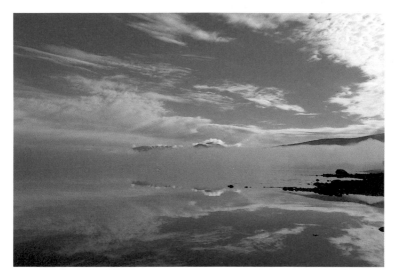

Framing and composition are of the greatest importance. Even when the horizon is invisible, as in Duncan McEwan's shot here, the camera must never make the sea or a lake 'run out' of the picture.

IF THERE is one fault which ruins more landscape photography than any other, it is not taking sufficient time to frame, focus and expose the image carefully. With a small amount of equipment, and a rigidly imposed discipline of using the camera on a tripod wherever practical, it should not be difficult to take a little time ensuring that what you see through the viewfinder is exactly what you want to get on the film.

Setting Up

Composing the image is vital if those ideas which are in the mind are going to be communicated through the picture.

The simplest mistakes are the most obvious to the viewer – a lake, or the sea running downhill because the camera was not level. Hand-held, and with an ultra-wide lens, it is almost impossible to ensure a level horizon visually. A clip-on spirit level will do the job quickly and without any doubts being left in the photographer's mind. If it is difficult to clip a level onto the camera, then either get a tripod with built-in levels, or set the tripod up with a small DIY spirit level on the camera platform before attaching the camera. Your viewers will forgive you

many other mistakes, but a tilting skyline cannot be taken seriously.

With the camera firmly on a level tripod, the success of the photograph as a picture depends on composition – making sure that only what you want to include is included, and in the way you want it to be. How that composition is recorded photographically depends on your mastery of the camera controls.

Focusing

Controlling sharpness is vital in landscapes. Normally, it is distracting to have areas of unsharpness in a landscape. It is not natural, and therefore should only be included for carefully considered reasons.

Even if your lens doesn't stop down beyond f/16, it is still possible to get extensive depth of field by using the hyperfocal distance technique. The hyperfocal distance is the closest focusing distance for any given lens and aperture which still retains objects at infinity in sharp focus. Every lens is normally supplied with an HD table, and it is useful to carry it with you – or use the markers on the lens barrel if it has them. A wide angle lens of 28mm focal length on a 35mm camera set to f/16 has a hyperfocal distance of about 5 feet. That is, when the lens is focused on five feet, objects at infinity will still be reproduced in

sharp focus.

However, as depth of field extends in front of the plane of focus as well as beyond – and extends in front by half the distance from the focused plane to the camera itself, sharp focus will be achieved from 2ft 6in to infinity. The hyperfocal distance moves further away from the camera as aperture size is increased, but still allows greater depth of field than that available with the camera focused on infinity. The hyperfocal distance technique is used extensively by all successful landscape photographers.

Metering

Most light meters are designed to average the light received by them, and present the photographer, or the automatic controls of the camera, with information designed to produce a constant level of exposure. Thus, if you see two scenes, one brooding and heavy, the other light and airy, the meter will average them out so that when you photograph them the prints will have the same sort of density. In other words, the very differences which tempted you to take the pictures in the first place will be compensated for by the meter.

Using a light meter creatively is an essential prerequisite of good landscape photography. The term 'exposure meter' has

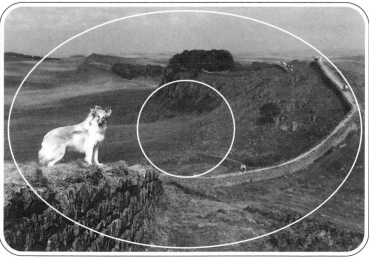

Most cameras focus using a central spot (top) but meter the light using centre weighting (bottom) where the outer areas of the picture do have some effect on the reading. Photographs by David Kilpatrick.

been imposed onto light metering devices as if they have some in-built ability to assess the right exposure. They do not. They are simply light measuring devices, and what photographers do with the information they are presented with by their meters is up to individual tastes and requirements.

It follows, therefore, that the photographer must have a clear idea of what the finished picture is to look like and an ability to relate that idea to the light actually falling on or reflected from the scene to be photographed.

Reflected vs incident

Light meters fall into two types – reflected light measurement, and incident light measurement. In the former, the light coming back from the subject to the camera is being assessed. And this is how most built-in exposure meters work. In the latter, it is the actual light falling on the subject which is being measured . Normally incident light measurement is the more accurate with hand-held separate meters, but it has limitations.

The use of reflected light readings from a dark subject will result in the over-exposure of that subject, and equally in the under-exposure of a very highly reflective subject. Incident light measurement would result in more accurate assessment of the

exposure required for both.

Incident measurement requires the meter to be pointed from the subject towards the camera. In normal sunny conditions, pointing in a line from subject to camera will result in correct exposure for the semi-shadow mid tones of the subject. Pointing towards the sun will correctly expose the highlights. Rather than actually walk into the scene, most photographers take the reading from the camera position and simply aim the meter in the right direction.

Incident light measurement cannot cope with shots into the sun, or almost into the sun. For these views direct light measurement modified by the photographer's preference must be employed. The meter will give an average exposure reading, but as backlit or contre-jour subjects are usually of excessively high contrast – a brightness range of up to 4,000,000:1 when most films are best at coping with 128:1 or less – such an exposure estimation would result in over-exposed highlights and under exposed shadows. Only the mid-tones would be correctly exposed. It therefore falls to the photographer to judge which parts of the subject brightness range are most important, and to modify the metered information to ensure that correct exposure is where it matters, leaving either the highlights or shadows to take care of themselves.

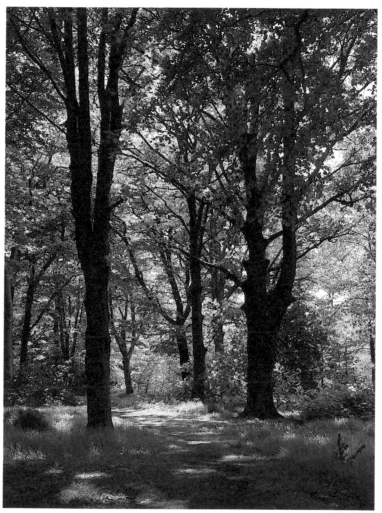

Film can only cope with a limited range of contrast, so it is important to use a light-meter carefully when taking a shot like this (by John Hannavy). A careful compromise, or average exposure, retains just enough detail in the sunlit patches and the leaves while keeping a hint of texture on the dark tree-trunks.

23

If it is the shadows and near-shadows which are most important, it is often better to move in closer with the meter and take a light reading with the cell shielded from the direct glare of the sun. That way correct exposure for the shadows will result, with the highlights burning out to a detail-less halo or white.

If the sky – including the sun – is most important, then accept that everything else will fall into solid silhouette.

Contrast

Image contrast is controlled by the nature of the light. Clouds act as a giant diffuser – so the thicker the cloud, the softer and more even will be the light.

Bright sunlight in a cloudless sky is very high contrast. Even with the sun behind the camera, photographs taken in this sort of light will have dense solid shadows. If there is any trace of detail in the shadows, it will be blue – for those areas out of sunlight will be lit solely by light reflected from the blue of the sky.

A thin veil of cloud softens the light considerably – opening up shadows but also considerably lightening the sky.

A sky with distinct white clouds and clear blue sky will produce good sky detail, together with neutral shadows – as this time

white light from the clouds will throw a little light into them.

Overcast skies produce the lowest contrast of all – and also a very cold light. In black and white photography that low contrast can be boosted by printing on a harder grade of paper, but in colour the contrast cannot be artificially raised. However, by the inclusion of areas of colour, acceptable images can be produced even on very dull days. Contrast can also be apparently increased by taking pictures from underneath trees and so on – so that darker areas are introduced to widen the tonal range of the pictures.

Shutter Control

For a lot of photography, consideration only really has to be given to shutter speeds if they affect the ability either to hand-hold the camera, or of subjects to stay still. In the landscape, however, the shutter speed dial of the camera plays a much more fundamental role.

With the camera fixed on a tripod, the shutter speed range is used not only to make sure the camera stays steady, and to freeze movement – caused by wind and so on – but also to impart particular qualities to the moving elements within the picture. A sense of movement in long grasses being blown by the wind can be a very useful addition to a

A scene photographed on a sunny day with no clouds has dense black shadows (left) but one photographed in overcast light (right) shows detail throughout. Sunshine with white reflective clouds is often ideal.

picture – blurred blown grasses in an image where everything else is sharp can be very effective.

Like any other aspect of the camera's control, shutter speed can never be considered independently of aperture, depth of field and so on.

Short exposure times are very useful when hand-holding – but a tripod should be used whenever practical.

Long exposures may be used to introduce subject movement, but they may also be imposed by the requirement for a small aperture to effect the required depth of field. A balance, therefore, between the need to restrict blurring within the frame while at the same time maximizing depth of field must always be considered. If a sacrifice has to be made in one or the other, it should be a considered rather than an accidental sacrifice.

Under low light the problems become even more acute – with long exposures coupled with large apertures being required, unless much faster films are available.

Different shutter speeds also impart different characteristics to any moving objects within the frame, and these will be dealt with in a later chapter.

Filters

A brief mention of three essential filters was made in the "Setting Out" chapter, and although those three are essential, there are others which are useful additions to the kit.

UV-haze and skylight filters are, in the opinion of most photographers, essential whatever the subject matter and the weather conditions – either for their photographic value, or just for the protection they give the lens by always being in place.

Brief mention has also been made of polarizers and graduates and they too have considerable and important uses. The next most useful range of filters are Neutral density filters – allowing the photographer to reduce the amount of light reaching the film, and thus extend the ability to combine a given aperture with a long exposure, irrespective of the lighting levels at the time.

Vario-ND filters are the most useful in this respect. These are really two polarizing filters which can be rotated in opposite directions relative to each other. As they are rotated one way, the polarizers cancel each other out – reducing progressively the light transmission characteristics of the sandwich.

Other filters such as fog, soft focus, starburst, split field, multi-imaging and so on, have little place in the kit of a photographer who likes the challenge of interpreting rather than changing the landscape.

For black and white photography, there are a number of filters which control the tonal relationships within the image. The traditional 2x yellow is a good standby for enhancing skies without really having much effect anywhere else within the picture.

The range of filters – yellow, orange, red – all do the same job, but with varying degrees of influence elsewhere within the picture. Yellow only affects the sky, while orange and red have a slight and considerable effect respectively on the greens of grass and foliage. A red filter will considerably darken skies and darken green leaves, grass etc at the same time. Ripe corn, dried grass, sand and so on will be lightened – altering quite dramatically the tonal relationships which we normally associate with the landscape. Yellow-green and green filters, by transmitting green more easily than blue, will darken skies relative to foliage. As blue sky is in fact blue/green, the yellow/green filter will have a greater effect on the sky than a pure green, while both have a similar effect on leaves and grasses.

Used sparingly, they can be very effective. Any filter used excessively loses impact.

A graduated filter can deepen an everyday sky to add drama: photograph by David Kilpatrick.

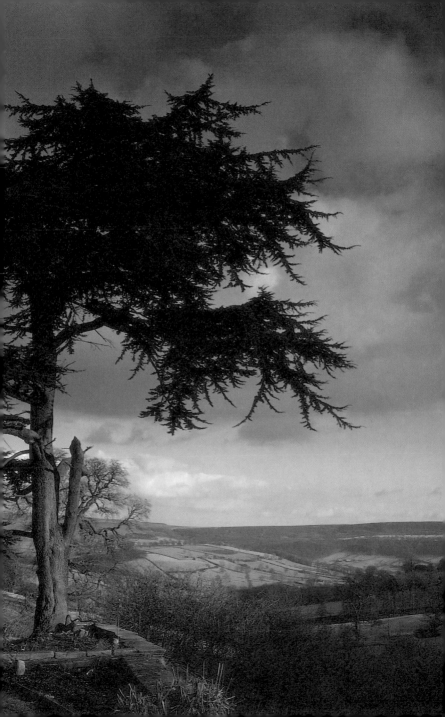

3: COMPOSITION

Though no modern camera has yet incorporated automatic composition, it can help to imagine lines roughly one-third into the frame. Their intersections are the points of strongest visual impact.

MODERN technology ensures that today's photographer has few problems with exposure and now in some cases focusing has also been taken out of his hands. Increasingly it would seem that one need only point and shoot to get acceptable results. Although acceptable, many such pictures will quite likely be lacking in that vital ingredient we call composition. Composition is entirely in the charge of the photographer and no camera has so far been designed that will do this automatically. Hopefully there never will be, because it would lead to stereotyped pictures, completely lacking in any personal touch or individual interpretation of a landscape subject.

While different focal length lenses can be of value in creating different compositions, it would be quite wrong for the compact camera user or the SLR-plus-standard-lens owner to think that consideration of composition is not relevant for his purposes. All photographers, irrespective of their equipment, can improve landscape photography by learning and thinking about composition. After all, composition is to photography what grammar is to language – both are essential for successful

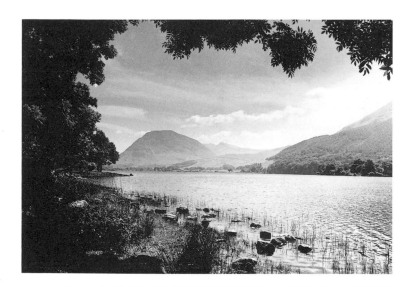

Composition is helped by the use of foreground framing (top) which may be sharp, as here, or blurred. Reducing perspective of detail (bottom) helps lead the eye into an otherwise plain composition.

29

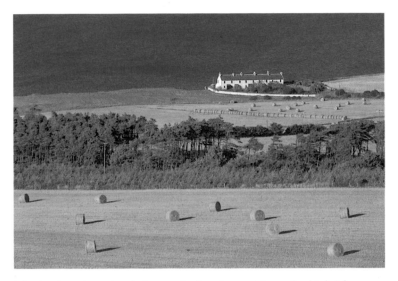

The horizon is a visual element in the picture. It can be high (above, formed by the shoreline) or low (right, formed by the mountains) but should rarely be exactly central. Photographs by Duncan McEwan.

communication.

When taking a landscape we should be aiming for a careful arrangement of the component parts of a scene (trees, rivers, mountains, rocks, fences, animals, clouds and so on) within the picture area. Such elements should be made to relate to each other in such a manner that they attract, hold and retain the attention of the viewer. If you can achieve this you'll have a good composition.

One thing we should realize is that, while we can speak of good or weak compositions, there is no right or wrong. Nevertheless there are some "rules" that are

worth following, at least to start with. Once the beneficial effect of these has been appreciated you'll not wish to adhere rigidly to them, but rather to use them as guidelines from which to branch out and experiment.

The horizon

One of the most important aspects of landscape photography is placement of the horizon. The beginner will almost invariably place the horizon across the middle of the picture. This is probably the worse place to have it as it rarely provides a successful composition. You can however,

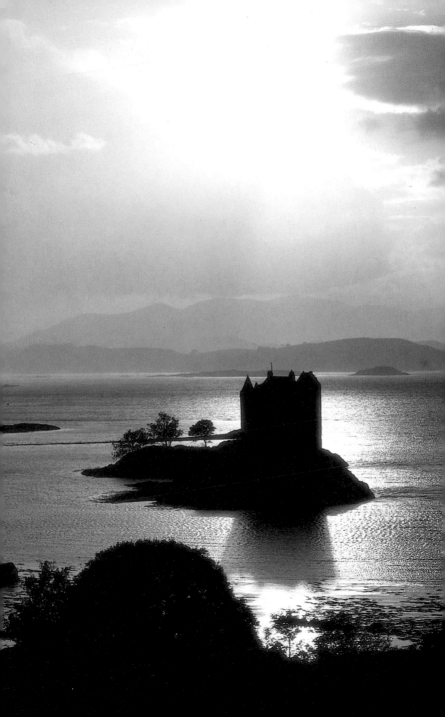

Even when the horizon is curved, the true visual horizon must stay level (above, by David Kilpatrick). For dramatic impact, the horizon can be omitted completely (right, by Shirley Kilpatrick).

sometimes get away with it if other compositional aspects are sufficiently strong to compensate. A central horizon in the scene can be made less obvious by the inclusion of overhanging tree branches or other framing elements. It can also work with some reflection pictures where mountains are mirrored in a still lake, or in very formal and symmetrical compositions where the aim is to create a feeling of space, emptiness or tranquillity.

It is generally much more satisfactory to position the horizon according to the "rule of thirds", so that it is one third from the top or the bottom of the picture. This gives a much more balanced picture.

The decision of whether to go for a third sky to two thirds land or vice-versa requires consideration of the relative weightings you wish to give these two areas. If the sky is interesting consider making it the dominant area, but if it is weak, light or plain then it is better to give emphasis to the foreground. Having the horizon even closer to the edges of the frame has probably provided some of the most dramatic compositions for photographers skilled enough to exploit such an imbalance.

Going one step further,

complete elimination of the sky may even be worth considering, particularly where the sky colour is very weak or if you wish to concentrate attention on patterns, shapes, texture or colours in the landscape. Colours and tones are emphasized when there is no area of light sky to make them appear dark, and winter landscapes in particular can be improved by keeping the exposure to a minimum and cutting out a plain white sky.

Wherever you choose to place the horizon make sure it is horizontal. If the camera isn't held level, sloping horizons will result and will look most disturbing to the eye.

Focal point

Most successful landscapes have a clearly defined focal point or centre of interest – it may be a tree, a building, a mountain peak, a boat. Arrangements of the other elements in the picture should lead the eye to this centre of interest. If it doesn't, then the composition is not as strong as it might be. One of the points where the horizontal and the vertical thirds intersect is generally regarded as an ideal position for the centre of interest. Once again it is best to regard this as a guideline rather than an infallible "rule".

Another important compositional consideration is the creation of depth or perspective – the suggestion of a third dimension in the two dimensions of a picture. The idea that a landscape should have a foreground, a middle distance and a background is a useful one to remember as it will go some way towards creating depth. Leading lines will strengthen this geometric perspective. Roads or rivers narrowing into the distance will lead the eye into and through the scene. So too might the diminishing size of trees, rocks or fence posts as they fade into the background.

Atmospheric haze or mist will give a similar illusion of depth by softening the background details compared with the clearly defined foreground elements – this is known as aerial perspective. Wide-angle lenses are extremely useful for shots like this because they greatly accentuate the feeling of depth and exaggerate the scale of the near objects relative to more distant ones. Sometimes when mist is too thick to allow photography at a distance, a wide-angle can be used to get close enough to the ground and foreground objects to record them clearly, letting the entire background scene remain plain white.

It's a mistake to use wide-angle lenses just to cram more objects into your pictures. You must try to organize these objects so that they relate spatially to each other. Strong foregrounds

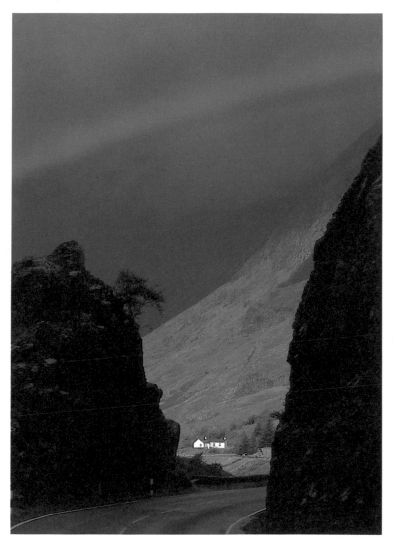

A medium telephoto lens gives the mountain pass weight – but it is the small white building overshadowed by the storm which acts as a focal point and holds the eye. Photograph by Duncan McEwan.

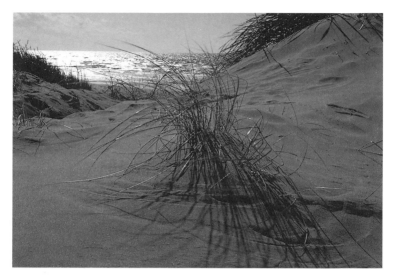

When using wide-angles, always include a strong foreground and stop down to get maximum sharpness (above). The square format offers an alternative on rollfilm (right). Photographs by John Hannavy.

are absolutely essential when using wide-angles and the first-time user may experience disappointment because insufficiently strong elements have been included in the foreground. This will also apply to the users of compact cameras as most of these are fitted with lenses having a focal length of around 35mm.

Lens choices

To attain adequate sharpness throughout the scene use a small aperture. If your lens has a depth of field scale, use this to indicate the aperture needed and the correct hyperfocal distance to focus on and cover the depth of the scene. Small apertures may necessitate slow shutter speeds, in which case a tripod should be used. However, slow shutter speeds could create other problems such as foreground blurring of moving water of wind-blown vegetation. In most cases, out-of-focus foregrounds are not a good idea and should be avoided.

Compared with wide-angle lenses, telephotos will flatten the perspective giving little in the way of the sought after third dimension. This is largely because they limit, or eliminate altogether, the foreground part of

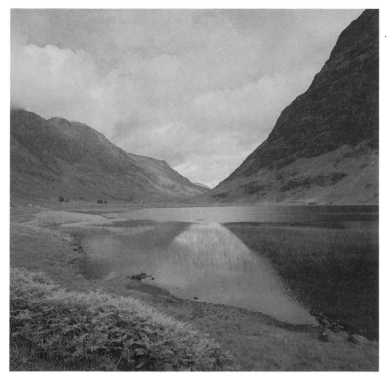

the landscape. Telephotos are, however, extremely useful for isolating interesting elements in the overall landscape. Zoom lenses, irrespective of what focal range they cover, are a marvellous aid when trying to compose a picture.

Quite often when viewing a landscape with the naked eye it's not easy to visualize where the best picture lies. Survey the scene through the viewfinder – swing the camera left, right, up and down. You'll find it much easier to compare the compositional possibilities. Remember to try the vertical and square formats as well as the horizontal one. It's well worth investigating all the options available before pressing the button.

This chapter will hopefully have demonstrated just how essential good composition is in landscape photography. Get both this and your lighting and exposure "right" and you've probably got yourself a winner!

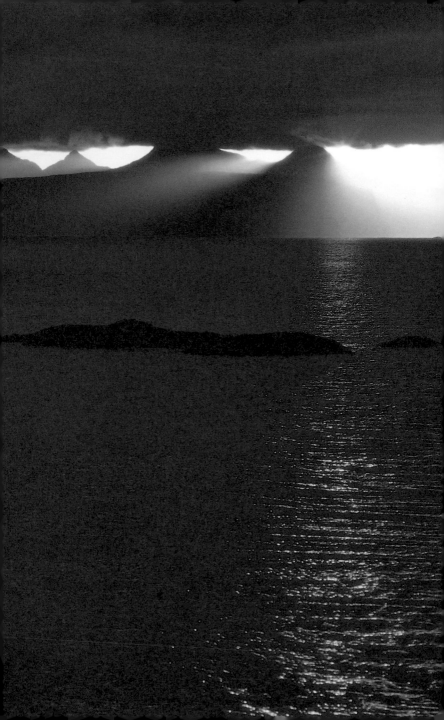

"THE SUPREME test of the photographer, and so often the supreme disappointment" was how Ansel Adams described landscape photography – and he was one of its greatest exponents.

Perhaps this is because landscapes are too easily taken, even by the novice possessing the simplest of compact cameras. There's no real necessity to have telephoto or close up facilities as you would for sport or nature photography. It's all too easy to point and shoot.

Everyone who goes on holiday with a camera will almost certainly return with many landscape pictures documenting places visited. These pictures may be sharp, well-exposed and bring back happy memories, but in photographic terms they are likely to show considerable scope for improvement. What is it that would distinguish these photographs from those of the more serious or professional landscapist? There could be deficiencies in composition, choice of viewpoint, lighting effects, use of colour or just a general lack of what we call 'mood'.

Left: the quality and mood of light in a scene can be the single factor which makes a successful photograph. This is why sunsets are often worth waiting for. Here, Duncan McEwan has waited for exactly the right moment before taking the picture.

Light matters

In all aspects of photography, the quality and direction of light is of great importance, but in landscape work it is an even more vital ingredient – sometimes being the complete picture in itself. It doesn't really matter if there's no foreground or no small boat to form a centre of interest in a picture of a storm over a lake, as the picture is all about the dramatic quality which unique lighting conditions create.

One of the great problems for the landscape photographer is that there is practically no way of controlling how the scene is lit. In portraiture, for example, one can normally position the subject, or the light sources, to achieve the desired lighting effect. With landscapes you have no means of altering the light other than waiting patiently for it to change naturally, hour to hour, day to day, season to season. Different times will produce quite different photographic opportunities.

In some cases a landscape may only be 'correctly' lit for a few hours each day or for a few days in the year. Therefore to exploit a particular location to the full, you have to see it in different lighting conditions and several visits will have to be made, to the dismay of the tourist snapper.

So what kind of lighting conditions should we be looking for and what can we expect each to achieve?

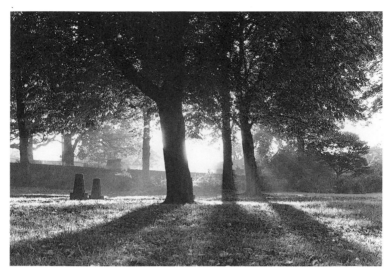

Evening light produces the most attractive shadows and textures in black and white, and warm colours with slide film. It is better to avoid mid-day sun in summer. Photograph: David Kilpatrick.

Prevailing light

Dull, grey, overcast conditions are rather uninteresting, producing very flat lighting, but they can be advantageous if you are trying to capture delicate tones or colours. Strong overhead sunshine will give saturated colour with harsh colours but it too creates rather a flat feeling. Looking into the light (contre-jour) can be recommended when shooting across water or where there's snow, frost or dew on grass, but it is unlikely to work as well if shooting large solid land masses such as mountains. Low directional light will emphasis texture, outline the contours or form of the land, create long but softer shadows and generally produce a much more interesting picture.

This is why, at least in summer, landscape photographers prefer to shoot in early morning or late afternoon/ evening, so avoiding the harsh flatness produced by the midday sun. At other times of the year the sun is low enough in the sky all day to give sufficiently directional lighting.

Using light to selectively illuminate just a small part of a scene is a particularly powerful technique in landscape

photography . In mountain areas in particular the clouds may be broken up and allow shafts of sunlight to pick out fields, trees or ridges individually. Sometimes the overall contrast will mean that most of the rest of the scene is very dark. This kind of lighting is really exciting, but it may last for no more than a few brief moments. The photographer must react quickly or the effect may be lost. Shoot first, think later; or at least start shooting while you're thinking! Composition must take second place to getting the exposure correct. Exposing for the highlight area is essential, even although it might lead to loss of detail in the unlit areas and render the sky darker than it really was. It only serves to heighten the atmosphere.

Spot Metering

If your camera has a spot metering facility then use this to take a reading of the highlight area, although bracketing the exposure in such tricky lighting conditions is always advisable. If done sensibly it needn't involve a lot of extra film. Don't automatically bracket plus and minus from your indicated exposure. Think about what you are trying to achieve and more often than not, you will find there is only need to bracket in one direction, plus or minus. e.g. 0, −1/2, −1, −1 1/2 rather than 0,

−1/2, +1/2, −1, +1, −1 1/2, +1 1/2.

There is no doubt that luck can play a major part in getting shots with dramatic lighting. Being in the right place at the right time is something the experienced landscape photographer, with an understanding of local weather patterns, often manages to achieve through anticipation. Stormy days may be unpredictable but they can be richly rewarding in the search for dramatic landscapes.

Colour changes

Light and colour cannot easily be disassociated from each other, for as the light alters in the course of a day so does its colour and this has a bearing on the mood of the picture. Light and colour probably make an equal contribution in determining mood.

Although you can never alter the prevailing lighting conditions in a landscape, that's not strictly true when working with wide-angles. In a few instances, it may be possible to use fill-in flash to brighten up a small, very close foreground. Using fill-in flash can give the illusion that the sun is just catching parts of the view nearest the camera, making a much stronger foreground. This is a technique worthy of experimentation and with care can be used to produce fairly natural looking effects. You can fit a warm-up filter to give the

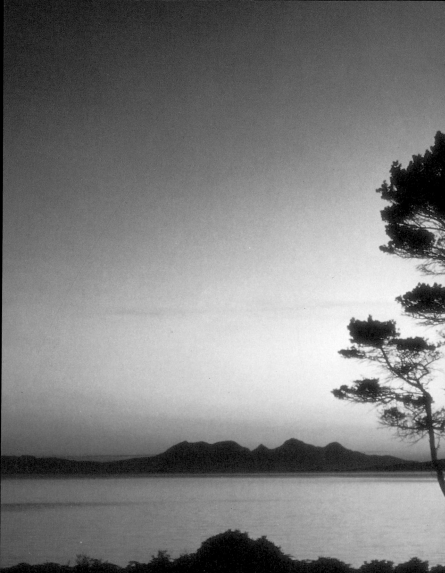

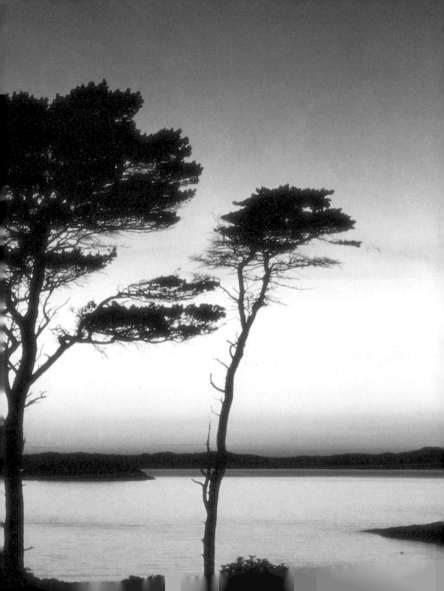

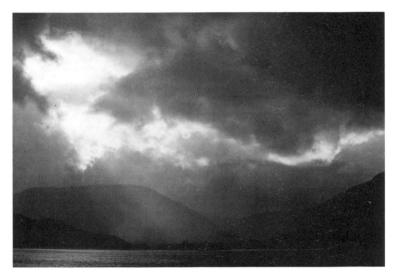

Try to use rainstorms and bad weather creatively in your landscapes, even if this means photographing the sky rather than the general scene. The light can be very dramatic. Photograph by Duncan McEwan.

impression of sunset light.

Of course, once the sun is well down and true dusk descends there is still scope for landscape photography. As with all scenes of high contrast, watch your exposure. An overall meter reading of a scene at dusk will give too generous an exposure, resulting in the semi-darkness effect being completely lost. Underexposing by 1 1/2 - 2 stops

Previous page: Duncan McEwan photographed pines at Roshven, Inverness-shire, at 11.30pm in mid-July using a half-second exposure and 24-35mm lens. The colour is completely natural.

gives the best results in most cases.

Try to be more adventurous in your landscape photography. Make use of rainstorms, snowstorms, rainbows, sunbeams and mist and try shooting at all times of day and throughout the seasons. Much as we criticize the climate in Britain and most parts of Europe, we should at least on occasions appreciate its changeable nature, for without this our landscape opportunities would be much impoverished. Readers in the USA and warmer climes may find life more predictable from month to month, but not as interesting!

5: COLOUR

WHILE LIGHTING conditions and good composition are undoubtedly the two main considerations in landscape photography, we must also be conscious of the role that colour can play in producing successful landscape pictures. Good use of colour can make a very significant contribution to the mood of a scene.

Much of the colour will be contributed by aspects of the land itself, such as the fresh green vegetation of spring and summer or the rich yellows and browns of an autumnal landscape. Superimposed on this will be the quality of the prevailing light which alters in its colour balance during the course of each day. It's therefore quite likely that, from the same scene, several different colour compositions can be created within the one day. The warm colour of the light just after sunrise and shortly before sunset creates a quite different mood compared with the clear light in the middle of the day. Equally one can compare the saturated colours produced in bright sunlight with the much softer colours presented by the same scene on an overcast day.

Such considerations, coupled with the eerie light often encountered before, during and after a storm, perhaps even with a rainbow included, are some of the other colour opportunities available to the landscape photographer.

Single colour scenes

A landscape which is restricted to one predominant colour will usually create a very definite mood or emotion and different effects. This can be seen by comparing the mountain snow scene overleaf with the sunset seascapes featured in the last chapter; the rich orange colour of the sunset (at sea level) produces a warm inviting quality while the blueness of the snowscape (accentuated by altitude) will give a pronounced feeling of coldness, bleakness and depression to the scene.

A strong blue colour is entirely natural in dusk scenes even on overcast days, and is fairly typical of conditions after the sun has long since set. Any colour in the landscape is lost, and the scene takes on a strong blue cast. Slight underexposure helps to enhance the feeling of nightfall in dusk shots. The same applies to sunsets, but here it pays to bracket the exposure as very different effects and moods are created by different levels of colour saturation. Sometimes, a graduated orange or tobacco-colour filter will improve a weak

Overleaf: after dusk, in snow, Duncan McEwan recorded the subtle blue shades of this church in Kintail, Scotland, with a 70-210mm zoom lens and slide film. The result is almost monochromatic.

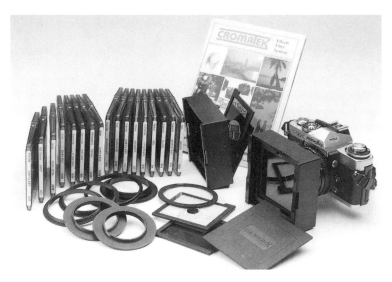

A filter system containing a number of colour balancing filters can be very useful for serious colour slide work (where adjustments can not be undertaken during printing). This is the Cromatek system.

sunset, or an 80B blue filter, normally used with daylight film in tungsten light, can make a dusk scene a richer shade of blue.

Green is the natural predominant colour in many country landscapes, and it is not affected as much by the quality of light as the time of year. Dark blue-greens are predominant in high summer, and may look almost black in some shots; golden or bright greens occur both in spring and autumn, and at these times the light is also likely to be clearer and slightly warmer in colour temperature. There is more variation in the green shades of a landscape towards the

beginning and end of the year. A polarizing filter helps bring out the subtle distinctions.

Bright colours

Having too many strong colours in a scene may well result in their competing with each other so that no clear mood is conveyed. In some cases this can be overcome by very careful composition – the relative sizes of areas of colour, where they are placed in the frame, how they are placed in the frame, and how they are placed in relation to one another.

On one occasion when photographing a rowan tree laden

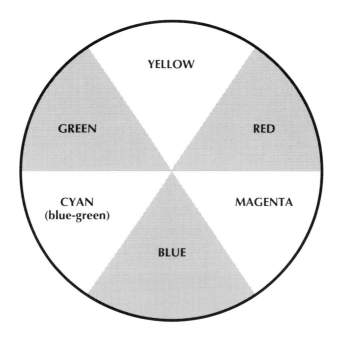

The complementary (opposing and balancing) colours can be used in combination in your pictures to ensure maximum contrast and impact. Photographs which contain a full set of either the subtractive (white in diagram) or additive (tinted in diagram) primaries seem very full and busy. Combinations of two dominant colours work better.

with red berries, several shots were taken that included an area of deep blue sky at the top of the picture. But they were much less pleasing than a shot missing out the sky completely, and showing the rowan against neutral-coloured rock – because the blue proved just too strong and detracted from the main subject of the picture.

Had it been possible to shoot the tree against the blue sky alone, much of this conflict would have been removed because the red would then have been in juxtaposition to the blue rather than being separated from it. The colour contrast would have been quite dramatic. By elimination of the blue sky, the red of the berries has become the dominant colour and the careful placing of the tree against the grey rocks helps to retain a small degree of colour contrast.

MUTED COLOURS

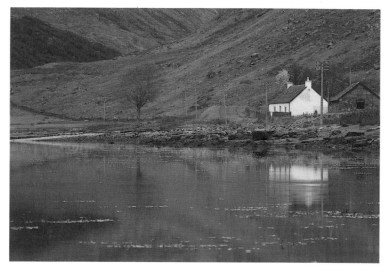

Above: a day of soft rain can produce muted colours, best exploited by looking for natural shades and omitting the plain white sky which would compete with their subtlety. Photograph by Duncan McEwan.

Fortunately, most natural colours are harmonious and the only clashes which arise are caused by competition between elements in the scene, not by incompatibility between the colours.

Careful composition can be used to ensure that red maple leaves are shown against blue sky (because in this case the contrast works) but subtle shades of heather picked out against a dark background, because any kind of colourful or bright sky area would overpower them totally.

Left – the rowan tree photograph by Duncan McEwan.

Muted colours

Dull overcast days are not always appreciated as being particularly suitable for landscape photography and yet, with careful selection of subject, quite interesting results can be achieved. When photographing a white cottage on a hillside in Scotland on a very dull day and in a soft steady drizzle, the colours in the hillside would be reduced to muted pastel shades with considerable colour harmony while the cottage itself would remain just the same white as on any other day. White looks better with muted colours than

bright ones, and more detail would be shown in the exterior of the cottage without harsh sun – so in this case, a muted overall scene would be preferable to a sunny day. Colour can be similarly muted by haze, fog, mist, dust and rain.

The impression of depth in a scene can be accentuated by introducing warm colours (red, orange, brown, yellow) into the foreground while the more distant parts consist of colder colours. The warm colours tend to stand out or advance towards the viewer and so the relative distance between the foreground and the background appears to be greater. Yellow gorse bushes or broom can be included in the foreground of many hillside views; by lakes or rivers orange hulls or buoys can perform a similar function. Many man-made objects which are important in the landscape – even the cagoules worn by walkers – are deliberately intended to stand out and can be used with care to pep up otherwise flat compositions.

The use of coloured filters is one way in which a photographer can impose his own choice of colour on a scene in order to create a personally chosen mood or effect. However, the results can often look rather artificial. Using colour filters for their own sake is not the best approach, but provided the situation lends itself to colour manipulation (and provided the photographer uses them with some sensitivity for the subject) they can be well worth having.

Filters

Graduated filters probably have the widest range of applications and are especially useful in dealing with pale uninteresting skies. A graduated grey is certainly the most natural to use as it won't introduce any additional colour, and a pale sky instead of turning out overexposed will assume a grey, perhaps even a stormy appearance. Similarly, a graduated blue will add a touch of blue to the sky while leaving the rest of the scene unaltered.

Other potentially useful graduated filters are tobacco, yellow, pink and mauve. For natural looking results, ensure that the colour introduced is in keeping with the light quality on the unfiltered part of the scene. When using graduated filters it is best to meter the scene before adding the filter as this will give a more accurate exposure.

When shooting colour there is one filter every landscape photographer should have and that is a polarizer. This will deepen the blue of the sky and enhance the colour contrast between sky and clouds. It will also cut out reflections from surfaces, leading to greater colour saturation. It is not always realized that a polarizer will

brighten many colours in the scene, including those of foliage, and general colour brilliance can be significantly improved.

There are two points to watch when using a polarizing filter. If it is turned to produce maximum effect, the sky may become unnaturally dark blue. Secondly, look out for any imbalance in effect across the span of the sky from left to right, with one half of the sky being dark and the other half very light. The latter effect will be most pronounced when using a wide angle lens.

Film choice

Finally, in the case of colour slide work the film you choose can have a very marked effect on colour rendering. There are big differences between the colour reproduction of films like Ektachrome 100 Professional and Ektachrome 100 Plus Professional. The 'Plus' is a film with a different colour bias, much brighter and less yellowish than the standard film. Fujichrome is often popular for landscape photography because of its excellent greens, but under certain conditions these can become overpowering.

In general, Kodak films tend towards very natural and muted colours, and are ideal when colour conditions are good to start with. There is no need to boost the shades of spring or autumn, and snow scenes call for strictly neutral recording; Kodachrome or Ektachrome both prove ideal. Dull winter days or high summer landscapes, in contrast, benefit from additional colour warmth and saturation; here films like Fujichrome 100 or Ektachrome Plus are a better choice.

Agfa's films have long been favourites amongst landscape photographers because they have excellent greens without excessive brilliance or saturation. They are now very neutral films to use, with the slower versions being far better than the medium and fast films.

With colour negative films the choice is open because the printing makes far more difference. Stick to films of ISO 100 or 200, and you will get far better landscapes than if you attempt to use fast films. Your choice of developing and printing service will have a much greater effect on the quality of your results.

Overleaf: putting theory into practice, Duncan McEwan used Fujichrome film with its naturally bright colour rendering, and restricted his composition to two principal opposing colours, orange and blue. The strong foreground placing of the orange emphasizes colour perspective; grey and natural green shades complete the colour palette, and a polarizer has boosted the overall saturation.

6: BLACK AND WHITE

Does colour translate to black and white? Often, the answer is yes. Reproducing the previous image in monochrome, its compositional strength remains but the perspective is not as obvious.

BECAUSE photography began in black and white, the traditions are as old as the subject itself. Today, monochrome landscape photography is as widely practised as ever.

From the days of Hill & Adamson, Roger Fenton, P H Emerson and the other great landscape photographers of the second half of the nineteenth century, the tradition stems in an unbroken line to the present day. To those names can be added hundreds more – Samuel Bourne, Carlton Watkins and many others from the nineteenth century, and from our own time Fay Godwin, Edward Weston, Bill Brandt and Ansel Adams.

Commitment to landscape – its preservation, its recognition as being an essential ingredient in our environment – is often central to the motivation of the black and white photographer. From Fay Godwin's pictures of the drovers' road of Wales, to Linda McCartney's pictures of the effects of large scale development, and Don McCullin's studies of the Somerset Levels, all are trying to draw attention to landscape, and provoke a positive response from everyone who sees their pictures. Black and white is far from a forgotten or neglected medium.

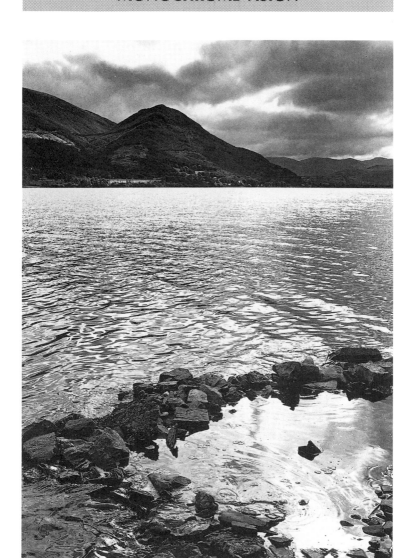

Black and white, in contrast, does not always translate to colour. This Lake District scene by David Kilpatrick was taken on a dull day, with overcast light and brownish-grey water colour – but it works in b & w.

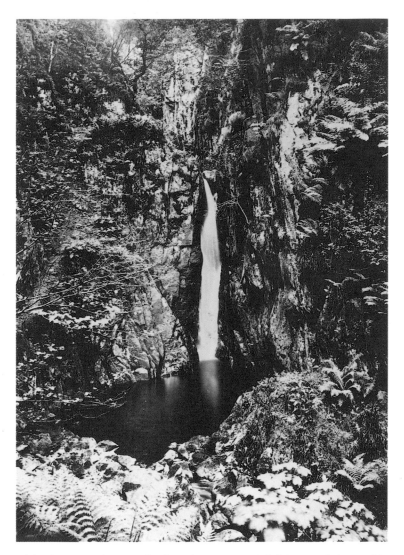

This Victorian photograph of Stanley Force in Eskdale, Cumbria, could almost have been taken one hundred years later. The sepia image-colour can still be produced easily (John Hannavy Picture Collection).

Given the right printing techniques – in this case careful shading using Ilford Multigrade III Deluxe – a 35mm negative can yield detailed and fine quality enlargements. 20mm lens, FP4: David Kilpatrick.

Films and Formats

The photographers mentioned here use as wide a variety of equipment and formats as you could hope to find. Edward Weston worked extensively with a 10 x 8in camera, contact printing (never enlarging) his images. Linda McCartney works with 35mm and rollfilm, most of the others with one or both of those formats. The format and the medium they use is the best for what they are trying to do, how they plan to do it, and the purpose for which the pictures are being taken.

If the pictures are for reproduction in a book or magazine a medium speed film from 35mm upwards will do the job perfectly well. If the pictures are for exhibition, the considerations are impeccable quality, fine grain and absolute sharpness. These are most easily achieved by the use of the largest practical negative size. A contact print from a very large negative is grain-free, pin sharp and if made carefully, can be faultless. Few photographers, however, can afford the luxury of a 20 x 16in camera!

If a large format like 4 x 5in is to be used, then a medium speed film will produce exceptional

For large prints,, a special slow film like Kodak Technical Pan used with a rollfilm (6 x 6cm) camera produces the ultimate quality short of shooting on 5 x 4" sheet film. Photograph: John Hannavy.

quality even at very large magnifications. For the rollfilm and 35mm user however only the slowest films will retain the sort of quality and detail necessary for large exhibition prints.

Knowing the use to which the picture is going to be put is essential before shooting it as it dictates materials, format and technique to a great degree. Slow films, such as Ilford Pan F or Kodak Panatomic X, will yield large exhibition quality prints from 35mm negatives if the camera is tripod mounted and exposure and processing are executed carefully and precisely. For even finer grain, chromogenic materials such as Ilford XP1 and new-generation conventional films like Kodak T-Max 100 are

For this grainy and unusual rendering, Hannavy used Kodak's 35mm High Speed Infra Red film with a red filter. The soft focus and sharp grain are intentional results from this specialist film.

very useful, producing a combination of higher speed and finer grain than previously possible.

All these films share the advantage of normal panchromatic sensitivity, ensuring that the tonal relationships between the greys in the finished image relate directly to the original scene.

Special Films

The ultimate in fine grain negative – Kodak Technical Pan film – offers even greater degrees of enlargement before grain intrudes. It is available from 35mm to sheet film sizes and can be enlarged 40x or more without any loss of quality. Special developers are recommended for Technical Pan to achieve the full potential of its unusually fine grain and sharpness.

Useful for occasional experiments in producing the dramatic landscape is Kodak High Speed Infra-Red film. This film can be exposed either through a red filter (recording the red and infra red in a subject) or through an IR filter which cuts out all visible light. It requires special development and produces unique visual effects which include black skies, white foliage and a crisp grainy image with a soft halo round many details.

For the rollfilm user, most of these same options are available, the most obvious exclusion being Infra Red. For that type of film, there is a rollfilm gap – with only 35mm and sheet film being available.

Enlargements

For a 20 x 16in print made from the full height of a landscape-format negative and assuming a degree of cropping at the sides where necessary, a 35mm negative has to be enlarged 16x. A 6 x 7cm negative has to be enlarged 7.5x, and a 6 x 4.5cm negative approximately 10x. A 4 x 5in negative, however, requires only a 4x enlargement to achieve the same print size. Each grain or clump of grains evident in the print from the 35mm negative will cover sixteen times the area covered by a similar grain or clump from the 4 x 5 negative, assuming the same film stock was used for both. Likewise, a speck of dust clinging to the 35mm negative will leave a white spot sixteen times the size of an identical speck on the 4 x 5, with at least that much degree of increased difficulty spotting it out!

In many cases, however, given maximum degrees of enlargement within the capability of the film used, the actual sharpness of the images may not be very different. Good 35mm camera lenses are made to finer tolerances than their large format counterparts, being designed with that greater degree of enlargement in mind. The major disadvantages of large

Many rollfilm cameras – and all large format sheet film cameras – accept Polaroid backs, which can be used to produce good quality monochrome negatives on the spot without processing.

format are undoubtedly the bulk and the weight associated with that bulk. A large format system with dark slides, case and tripod can approach forty to fifty pounds total weight if you are not careful!

As with colour, Polaroid has a very useful part to play in monochrome landscape work. Indeed, with Polaroid materials capable of producing a high quality negative as well as a reference print, the monochrome landscape worker can, on occasions, check not only composition and exposure, but processing as well on location. Polaroid neg/print materials are available both for the large format

user, and for the medium format worker with a Polaroid back.

Process control

One of the advantages of colour photography is the standardization of processing – nowadays most colour negative films go through C41 compatible chemistry, and most colour reversal materials through E6 or compatible systems.

With monochrome there is such a wide range of developers, each with distinct characteristics and processing cycles, that the skilled landscape worker can customize both film and

processing technique to achieve specific qualities. The relationship between film, exposure and processing technique controls the image quality, contrast, sharpness and subtlety.

In the absence of colour, impact and visual clarity must be created with tonal variation alone. Whereas colour immediately introduces a visual contrast, even under flat lighting conditions, the same is not possible with monochrome. What is thought soft, subtle and intriguing in colour, can be labeled flat and uninteresting in monochrome unless the photographer is very careful. Contrast must be restored either during exposure with filters, or during developing or printing. At each stage along the way, the photographer can control and manipulate the quality of the finished print.

Filters

Manipulating contrast with filters is perhaps the most common means of controlling the tonal relationships in the final print. To most photographers, however, it might come as a surprise to be told that this is what they are doing. The simple 2x yellow filter to enhance cloud effects is seldom thought of as a contrast control. Yet exaggerating the tonal difference between sky and clouds is indeed increasing the contrast. The 2x yellow is often considered a standard filter to leave on the lens for all sunny-day landscape work.

The effect of any filter is to stop light of the opposite colour being transmitted and reaching the film, while leaving light of the same colour unaltered. Thus a yellow filter stops blue – the degree to which it does so depending on the filter strength. As all light is made up of the three primary colours (blue, green and red) the yellow filter transmits red and green (which in light terms make yellow) unaltered. Grass, foliage, tree barks, earth and so on remain unchanged, while the sky darkens.

With a red filter, red light is transmitted unaltered, so the red component of any colour is not changed. Blue and green light are reduced or eliminated dependent on filter strength, darkening skies and foliage, but leaving sand, soil, wood and so on largely unchanged. The 8x red filter produces very dramatic dark skies, and lightens foliage because most plants reflect a considerable amount of red light. Cornfields and autumn colours are rendered very distinctively. Orange filters have a similar if less striking effect, and are more suitable for general use, especially on dull days when their haze-penetrating function increases overall contrast.

Green filters reduce the transmission of blue and red light.

These filters have a slight effect on the sky, a lightening effect on foliage, and a darkening effect on light colours which reflect red – sand, wood and so on. The 2.5x yellow-green is often recommended for summer landscapes when the foliage tends to be dark, and the 3x green for beaches, desert scenes, and mountain views with conifers.

You will probably find the 4x orange filter the most useful one for landscape work, combined with a wide-angle lens of around 28 to 35mm focal length on 35mm. On clear days with some white clouds and blue sky, this combination will give a very pleasant deep sky tone. With wider-angle lenses, a 2x yellow will be adequate as the sky darkens naturally towards its zenith; with a 50mm standard lens, try the 8x red filter for shots which only include sky close to the horizon.

Exposure

The ideal exposure for a black and white material is the minimum exposure which will retain all the required detail. Under-exposure loses shadow detail, over exposure clogs highlight detail. If detail is lost by inaccurate exposure in the negative, then some correction can be applied in printing, but it is not possible to put shadow detail back where none is recorded.

Accurate exposure in the camera is an essential starting point for a good picture. Grades of printing paper are available to manipulate the negative contrast for either personal reasons or to restore contrast variations caused during processing. They are not designed to restore faults introduced by poor exposure.

The key to success in monochrome is practice. With a particular combination of camera/film/developer which you are used to, which you understand and which you have taken time to experiment with, you are much more likely to be able to predict the effect on the final print of any changes in technique at the exposure or processing stage.

Be careful when using orange and red filters. Many SLR metering systems use light-sensitive cells which respond incorrectly to red light, and produce underexposed negatives. Though the camera is supposed to compensate automatically for filters, it is better to take a reading without the filter and adjust the exposure manually. Use the filter factor for this – one stop extra for 2x yellow, two stops for 4x orange, three stops for 8x red and so on.

Contrast

If you process your own black and white films, the relationship between exposure and development allows for slight

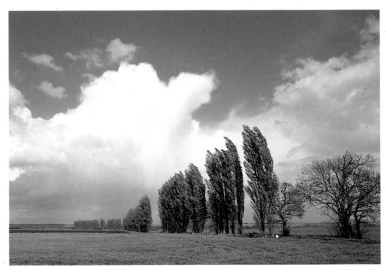

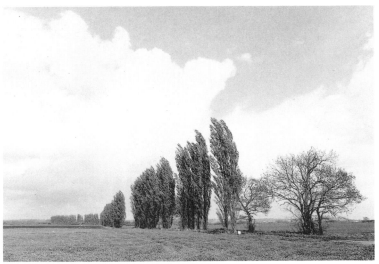

Top: a scene photographed on colour film has a deep blue sky and white clouds even without a filter. Bottom: normal black and white film (FP4) loses this effect entirely – the blue sky is much too light.

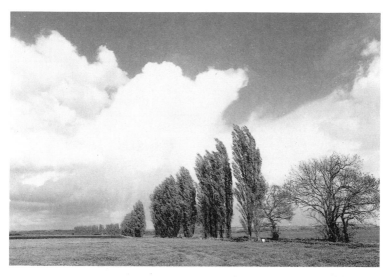

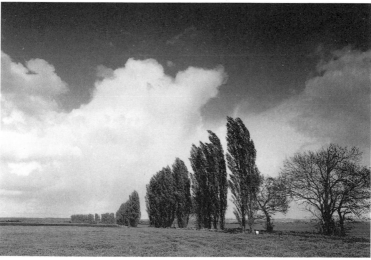

Top: using a yellow filter brings out the cloud/sky contrast to a normal level. Bottom: for dramatic results, a red filter deepens the sky almost to black. Photographs by David Kilpatrick (Minolta, 24mm lens).

under-exposure and over-development to increase contrast, and slight over-exposure and under-development to reduce negative contrast. If the day is dull to start with, you can decided to set your camera's meter to ISO 200 instead of ISO 125 and increase development by 25% (for example).

It can be better to use different developers for different conditions. A press-type developer like Kodak HC-110 is ideal for winter photography; a fine-grain developer with very soft results like Kodak Microdol-X is better for summer. There are many different fine grain developers, acutance developers, universal developers and a host of others.

Fine grain developers are the most widely used – and the most universally useful. Some of the ultra fine grain two-bath developers allow enormous degrees of enlargement to be achieved successfully from 35mm negatives, but do require some practice to ensure that they are used exactly according to the maker's specifications.

Acutance developers are not always fine grain, but tend to control contrast very successfully. They accentuate the difference between two areas of different tone by creating enhanced contrast where dark meets light, and therefore often appear to increase sharpness. However, for negatives where there are likely to

be areas of even tone – and landscape falls clearly into that category – their accentuated grain structure can destroy the natural feel of the image.

Such proprietary brands of ultra fine grain developers such as Leicanol are ideal for large exhibition prints from small negatives. The larger the negative format you are using, the wider the range of fine grain developers will you be able to exploit successfully.

Printing

The final choices have to be made at the printing stage. Enlarger type has a considerable effect on print quality – especially with small negatives. The use of a diffuse enlarger – either a specialist black and white head or a colour head – will reduce the visual effect of blemishes on the negative, but also slightly softens the image. The nature of exposure and development of the film should bear in mind the printing characteristics of the enlarger.

Printing paper comes in two types, fibre based and resin coated. While resin coated papers are easier to handle, there is no doubt that for large exhibition prints, fibre based papers produce a marked improvement in quality. The tonal range of RC papers is getting better with materials such as Ilford Multigrade DeLuxe, but it

RC vs FIBRE-BASED PAPERS

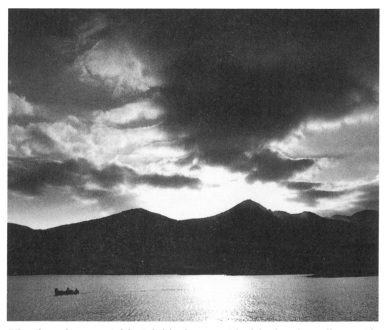

Fibre-based paper yields rich black tones, ideal for low-key effects with detailed but dense shadows. Archival processing gives the print a life expectancy of 100 years or more. Photograph by David Kilpatrick.

still falls far short of the richness possible with fibre based materials.

Fibre based papers give optimum quality at a price in terms of cost price and your own time. These papers have superb blacks, are capable of very subtle tonal ranges, are very stable and permanent. The quality they can produce is as high as you are ever going to find. However, they do require careful processing, and present drying problems. For exhibition work, there is really no other choice.

Fibre based paper can be toned in special chemicals to increase the richness of its tonal range, ensure archival permanence, or create a subtle colour tint in place of neutral black. The warm-brown sepia tone is familiar to most people, but few photographers use this simple process. Selenium toner is preferred for landscape prints and the image-colour tends to be a plummy brown-black.

7: THE CHANGING SEASONS

Spring is the best season for bright greens (above, by David Kilpatrick) with translucent young leaves – and for close-up photography of flowers (right, by Duncan McEwan).

ONE OF the greatest sources of variation in the landscape is provided by the changing seasons, each displaying its own particularly distinctive characteristics.

Spring

Spring is a season of great change in the landscape as fields, trees and hillsides lose their winter bleakness in favour of rich green colours, giving a feeling of freshness to the scenery. Because plants start their growth at different times and proceed at different rates, there is tremendous variety in the shades of green that are present. There will be other colours as well with flowers and blossom emerging.

The weather in spring is also dynamic, and this adds to the variety. It is one of the best times for sunsets; rainbows and sunny showers may be frequent; storms and skyscapes can be dramatic.

The sun becoming increasingly higher in the sky produces more varied lighting conditions over the course of a day. The quality of light is exceptionally good at this time of year and the atmosphere can have a remarkable clarity seldom found at other times. It is therefore an ideal time to pick out distant details.

In late Spring, beech woods still offer open enough lighting conditions for good pictures, and the young leaves are very bright in the sun. The exposure in these conditions is around four times that for a sunlit view.

Summer in the south of France – and an orange filter is vital to cut through the prevailing haze during the afternoon for a black and white shot. Both photographs by David Kilpatrick.

Summer

Compared with spring, summer can be rather a static season with little change in the landscape from one day to the next or even week to week. The rich variety of green will have given way to a darker, more uniform and less interesting shade. In many situations this is offset by an abundance of brightly coloured flowers.

Lighting is much harsher in summer sunshine, especially in the middle part of the day, and the hard shadows produced can be something of a nuisance. The heat of summer can produce a strong atmospheric haze and this can be used to add depth to scenes and effectively convey the feeling of distance. You won't be able to remove this moisture-haze by using a Haze filter, but a polarizer can have some effect in colour and a 4x orange will help in black and white.

When travelling abroad, remember that hazy conditions associated with warm weather may occur earlier in the year; the last truly clear days in the Mediterranean are often in May, while northern countries have better conditions even in late June. August is not a good time for photography – anywhere!

Autumn

Autumn, like spring, is a season of change as the greens of summer turn to yellow, brown and orange which then disappear with the onset of winter. This riches of colour, and especially the colour harmony in the vegetation, makes this season a favourite with most landscape workers.

Colour is only part of the appeal, for autumn also brings atmospheric conditions such as mists, frost, rainbows and storms. Mist, frost and overcast skies soften the colours and give very muted mellow tints, while clear blue skies provide a stunning contrast to warm saturated colours in the vegetation.

Because the sun never reaches the height it does in summer, good lighting for landscape photography will be present throughout the daylight hours.

Winter

Compared with other seasons, winter may seem a bleak colourless time of year, with little in the way of vegetation cover to add interest. Colour may be restricted but it does exist in more diluted and subtle forms.

Trees may look bare and uninteresting but in fact this is the best time for revealing their intricate pattern of branches when seen silhouetted against a clear sky in frosty weather.

The winter sun is so low in the sky that it may never reach parts of the landscape, especially in hilly regions. Where it does shine, long shadows are created and these are often the main feature of a winter landscape.

The light intensity is lower and the colour quality rather colder (bluer), but the air can often be very clear, in marked contrast a warm summer day. As a result you may find your best winter shots are sharper and crisper than summer equivalents.

Seasonal weather

Some weather conditions are firmly linked with the seasons, such as snow and frost with winter, mist with autumn. Others, such as rain, wind and stormy light are encountered to a greater or lesser degree all year round and so have a less seasonal flavour.

In landscape photography we should try to make full use of all these climatic conditions.

Rain

Wet weather is the kind of weather that most photographers like least, but it should be seen as a challenge rather than a source of frustration

Protect your equipment as best you can, perhaps enclosing camera and lens in a polythene bag, with only the front element protruding, and fit a skylight or UV filter and lenshood. Shoot

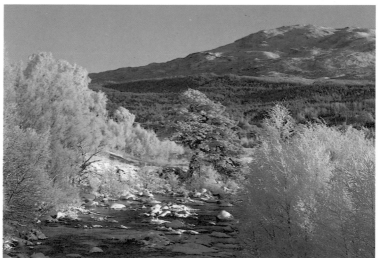

Top: low light and warm colours characterize an autumn view. Bottom: snow in winter – with sunshine for ideal photographic conditions. Photographs by Duncan McEwan.

WET WEATHER

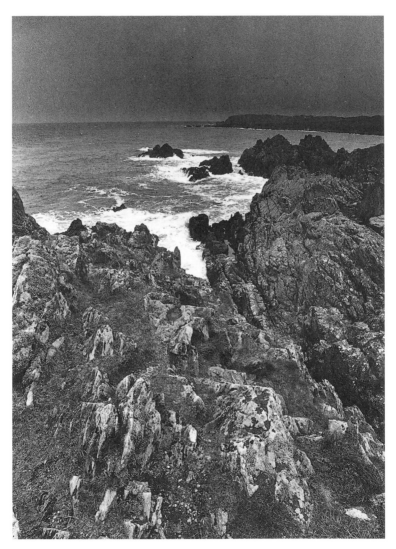

Rain and wet conditions do not spell an end to landscape photography: rocks and foliage can both look better in the rain than on dry, sunny days. Photograph by David Kilpatrick.

from underneath an umbrella, the inside of a car, under a tree or in the lee of a rock or wall. Avoid getting raindrops on the front of the lens as this will affect sharpness and they could show up in the picture.

On a dull, wet day, the lighting is flat, the colours muted and the definition may be rather soft. It may look too dismal for a picture but it shows the landscape in another of its moods - perhaps one that is all too familiar.

Falling rain seldom shows up in a picture unless it is particularly heavy and backlit. The interaction of raindrops and sunshine may produce rainbows, but to retain deep colours, always underexpose by 1/2 to 1 stop.

Snow

Snow has a romantic quality that photographers find irresistible. As far as landscape photography is concerned it is like icing on a cake.

The best time to photograph snow is often immediately after a fresh fall while the snow still sits precariously on twigs and wires or is plastered down the sides of tree trunks, poles and buildings. Go out at first light before sun or wind destroys this fragile wonderland.

A heavy fall greatly smooths the landscape and makes shadows more prominent. Breaks caused by footsteps and vehicle tracks will, when cross-lit, add

pattern and perhaps strong lines leading the eye into the picture.

If incorrectly exposed, snow will turn out grey and dull unless extra exposure is given. On clear days, between 1 and 2 stops more than the camera meter indicates should retain its white, sparkling quality. Excessive blueness, especially in shadows, can be corrected with an 81A filter. On dull days, snow is hardly worth photographing unless it is actually falling, producing a pattern of dots or streaks across the picture.

A dusting of snow can be just as welcome as a thick blanket and may give a quality akin to hoar frost.

Mist and Fog

Mist and fog introduce something of a creative element into landscapes by reducing colour saturation and contrast and giving a more ghostly atmosphere. By diminishing background details, depth and perspective will be enhanced, particularly if well-defined objects are included in the foreground.

The most exciting time is when mists or fogs are falling or clearing, allowing the sun to shine through. Thick static blankets are less interesting unless strong shapes, street lamps or car headlights are peering out from the gloom. Mist rising from the surface of water or looking down on to a mist-filled valley makes for good pictures.

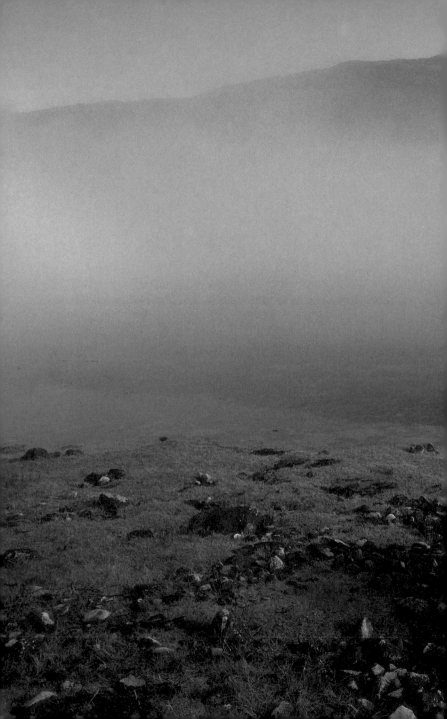

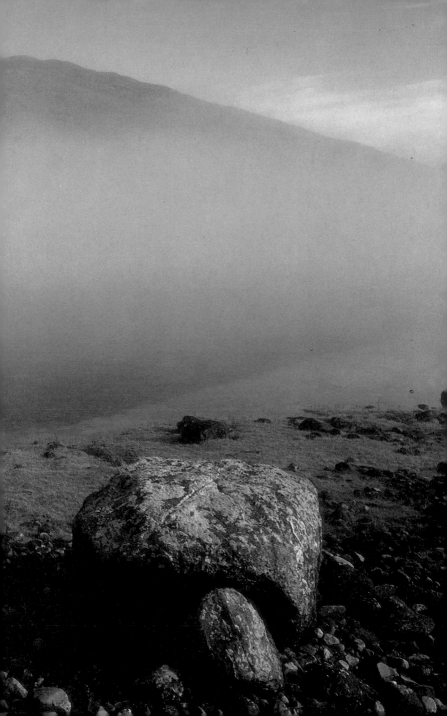

There is always an air of unpredictability about mist. It can be very local, and moving a short distance away can often take you into quite different conditions. Knowing whether to sit and wait for conditions to change or go in search of better conditions is always a difficult decision to make.

As with snow scenes, watch your exposure - a little extra (say 1/2 - 1 stop) gives an improved effect.

Wind

You cannot photograph the wind itself, but the effect it has on some parts of the landscape can inject an active element into a scene. The surface of water may only be ruffled by a gentle breeze but white tops, huge waves and spindrift are a clear sign of much higher winds. Wind-driven snow, rain or sand can be equally dramatic.

Fields of cereals show attractive patterns as the surface is swept by the wind and tree branches can often have a windswept appearance.

To arrest movement may require a fast shutter speed, although how fast depends of how close the subject is, and also on the strength of the wind. On the other hand, slow shutter

Previous page: rising mist over Loch Eil. Photograph by Duncan McEwan.

speeds (1/2 - 1/30 sec) can be used to emphasize the feeling of movement by creating a blurred effect. The camera would of course need to be securely mounted on a tripod for shots like this.

Stormy Light

Landscapes taken on fine days can often have a very static feeling, whereas stormy days possess a dynamic quality created largely by the lighting conditions. Looking into the light, as the sun breaks through a cloud-laden sky, can be a most exciting sight. The broken clouds and shafts of light may in themselves make a powerful skyscape picture.

Another dramatic form of storm light is seen looking away from the sun, as a greyish sky suddenly turns a deep blue-black when the sun strikes it. This will not make a picture on its own, but as a backdrop to a sunlit foreground or middle distance it gives one of the best impressions of storm conditions. This is also the type of sky against which rainbows look most colourful.

Storm light produces a high degree of contrast in a scene and to obtain the best effects.

Dawn and dusk

The beginning and end of the day are times well worth exploiting in your search for successful landscapes, as the hours around

sunrise and sunset have a quality all of their own.

In mid-summer, few of us rise early enough to experience a sunrise and so most shots of this type tend to be taken in winter or very late autumn/ early spring. Winter dawns often have the added charm of ground frost and the first rays of sun will give it a sparkling quality.

The time around sundown on the other hand, is witnessed almost all year round. Although we do not experience the midnight sun in temperate latitudes, it is often possible to continue shooting afterglow pictures until well after 11 pm in northern counties.

Light and Colour

The spectral content of daylight varies continuously throughout the course of a day as the sun moves across the sky. Even a small cloud, momentarily covering the sun, will alter the balance, so that it becomes fractionally bluer. Small shifts like this may not be detected by the eye but colour film is more sensitive and slight differences could show up. Correction using a filter need only be considered when the shift is more significant - such as a snow scene on a clear day.

Greater changes are evident in the evening with the sun low in the sky, when the light becomes very orange. The reason is that moisture and dust in the atmosphere deflect the blue wavelengths away from the earth. With less blue light reaching us the balance is changed so that the red colours become much more obvious. To compensate in this case, you would need to put some blue back into the picture by using an 82a (blue) filter, although the exaggerated warm colours we find are often the making of an evening scene.

Sunsets

The impact of a sunset picture depends on the degree of colour saturation, the cloud formations, the size of the sun and the strength of foreground shapes.

If the sun is to be the most important element in the picture, use a long telephoto lens (for example 300mm or longer) to ensure a large sun. Standard or wide-angle lenses are most effective when the attraction is in colourful cloud formations and broad expanses of water, or interesting foreground silhouettes.

Filters can be used to create stronger colours - "sunset", orange, tobacco or pink - but too often the results look rather artificial. A starburst filter can produce a good effect and works well when using a wide-angle approach.

A straight forward TTL meter reading will prove satisfactory provided the sun is outside the picture area, behind a cloud, or is

A FILTER-EFFECT SUNSET

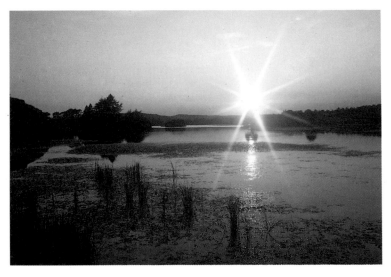

A sunset with a wide-angle lens will have a very small sun – so a starburst filter can help to emphasize the effect (if used occasionally). Photograph by Duncan McEwan.

very hazy. If a bright sun is included, a greatly underexposed picture may result. The best way is to take a meter reading from the sky, but excluding the sun.

Twilight

The half-light conditions that exist for an hour or so before sunrise and for a similar period after sunset are well worthy of attention. Twilight is often a period of great tranquillity with perfectly smooth surfaces on areas of water - ideal for reflection pictures. Tremendous colour graduations can be found, from orange at the horizon,

upwards through pink, mauve, violet to a deep inky blue overhead. Trees, buildings and prominent landmarks can make stunning silhouettes against such skies.

Twilight is also the ideal time for photographing scenes which contain artificial light sources such as street lamps, floodlit buildings and the lights of moving vehicles. Landscapes which include the moon are also best taken at this time.

Because light level will be low, long exposures may be necessary and a tripod should always be used. It will also be worth trying different exposures.

8: RIVERS AND LAKES

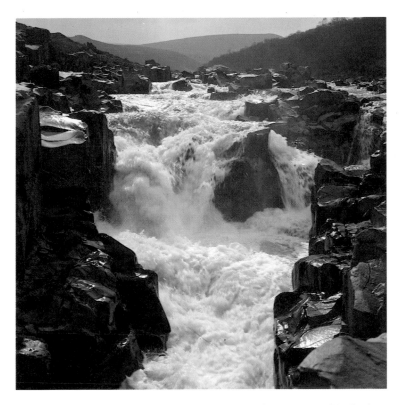

Rivers provide a touch of high-speed action in the countryside which can prove an interesting contrast to the natural transquillity of a square format composition. Photograph by John Hannavy.

THERE IS something about water in the landscape which enriches the view and affects our reaction to it. If water is going to be included in our landscape photographs, then it is essential that the technique used records the water in exactly the right way.

The essential characteristic of water is that it is liquid, which should govern the methods used to photograph it. The still photograph should convey that fact. Water is also capable of being very dynamic or perfectly still; it is reflective, it is transparent, it splashes, it shines, and it comes is a whole range of colours from clear blue to deep green or peat brown.

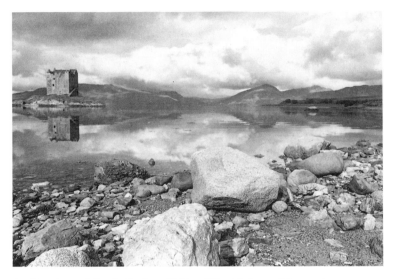

In this view of Castle Stalker, Shirley Kilpatrick used the rocks as a foreground and the distant mountains as a background – with a 28mm wide angle lens to produce the required perspective.

Composition

Rivers are a marvellous way of organizing how viewers 'read' landscapes. The natural meandering route of a river acts as a signpost through the picture. Naturally, the viewer will follow the river into the middle distance of the view and, if the composition is carefully organised – by selection of camera position and lens focal length in particular – the shape and direction of the river can be used to structure and control the order in which information is received by the viewer.

With large expanses of water such as lakes and lochs, the composition of the picture must be approached differently. Here the natural route is slightly less obvious – it is entirely dependant upon perspective. In order to convey the idea of space successfully, the composition must be based on linking elements of obviously different scale; small rocks in the foreground logically leading to mountain ranges in the distance, for instance. Reflections and the framing of trees are important when photographing views with lakes. Days with still water offer more opportunity for interesting shots than those with a breeze.

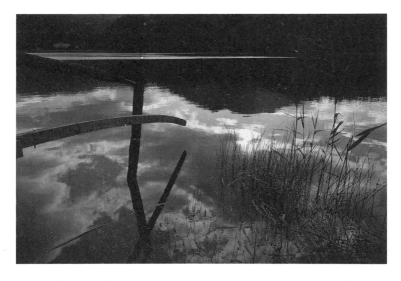

The quality of reflections in water depends on the lighting conditions and the stillness of the surface; a polarizer can eliminate unwanted effects. From a colour original by John Hannavy.

Light

Water, like glass, both transmits and reflects light. This can present problems with exposure, the high reflectance of water causing contrast problems as a very bright sky is reflected back at the camera. The calmer the water, the greater that reflectance will be, so the classic still lake picture is rarely possible under bright conditions. The best still water shots are often obtained when there is a slight haze in the sky or a thin veil of cloud having the effect of reducing contrast, opening up shadows and generally reducing the direct glare from the water.

There are a few occasions when shots under more intense and higher contrast lighting can be made successful by the use of a polarizing filter to reduce glare. The polarizer will eliminate not only the glare, but also the reflectant nature of the water which attracted you to the shot in the first place, and in the foreground you may see only the bed of the lake with little clue to the depth of water covering it. Using polarizers should be limited to a few occasions, and never at their full polarizing capacity. Somewhere between minimum and maximum

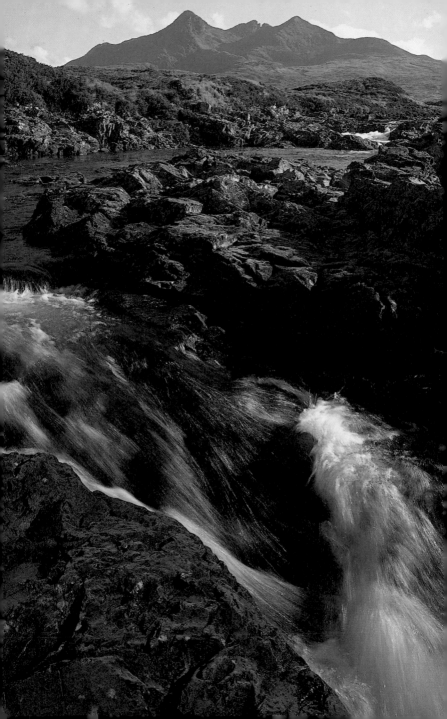

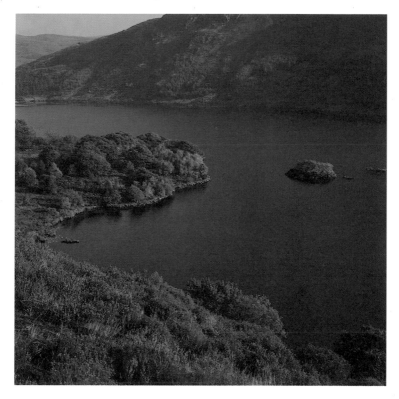

Left: rushing water with a longer than normal shutter speed. Above: if the sky is reflected in water, it will appear a deep blue, especially from a high viewpoint. Photographs by John Hannavy.

polarization should produce a pleasing effect which still retains the essential character of the water itself.

Reflections

The most variable aspect of water's character is its ability to reflect. What it reflects is dependent on several things – lighting conditions, wind level and so on.

The most usual reflection on water is a reflection of the sky, and that not only governs the textural appearance of the water but its colour as well. If the dominant reflection is a blue sky, then the water is blue. If it is a

grey sky, then the water will look deep, cold and forbidding. Still water is always bluer on a sunny day than rough water – for the rough water actually reflects a mixture of sky, landscape, mountains and so on. The colour it assumes is usually an approximate average of all the light colours it is reflecting – and that is most frequently a cold blue-green shade of grey.

The closer you are to the water, of course, the less impressive and extensive will be the reflections you see. As you move very close to the water, reflections may almost vanish and you will be able to photograph through the shallow waters at the edge of a lake or loch to the rocks on the bottom. Given a camera which allows you to manipulate focus carefully, you will be able to include both submerged foreground detail, and sweeping reflections in the distance into the same picture.

Creating Depth

Wide expanses of water – especially water of a fairly even tone – can assume a very two-dimensional appearance when photographed. It can often be helpful to include foreground detail which creates a sense of movement in the picture, implying considerable depth and distance between the first planes encountered in the picture, and those farthest away.

This can be achieved by a variety of means. A wide angle lens creates an exaggerated perspective in rocks in the foreground, creating a strong visual pull into the image. That movement will be continued by the viewer, so the sense of depth and distance will be reinforced.

The easiest method, however, is to create a visual contrast in the foreground. We expect nearer objects to be tonally stronger, and visually clearer than objects further away. By including finely detailed rocks, trees or other objects as a frame in the fore-ground, the effect of distance is greatly enhanced. Depending on the nature of the light, those trees could be silhouettes, or side lit and very textural. The effect will be similar – greater impression of depth will be introduced.

The use of framing detail has the additional quality of breaking away from the regularity of the rectangular film or print frame, introducing a note of freshness into the image.

Exposure

The way in which a landscape photographer uses the available range of shutter speeds for water subjects has an immense effect on the quality and attraction of the pictures produced.

For all the water shots you take, the earlier advice to use a tripod still holds. Try hand holding the camera for water

Two different approaches to a water cascade: left, 1/250 at f2.8 freezes water but blurs the rocks. Right, 1/2 second at f32 gives sharp rocks and fluid water. Minolta, 200mm Apo Tele, by David Kilpatrick.

shots and, apart from the usual risks of sloping horizons and water lines, shutter speed selection becomes influenced by the photographer's ability to keep the camera steady, rather than simply by the need to record the water with a particular quality.

Use a very fast shutter speed, and the surface quality which existed for that split second will be recorded like solidified glass. Use a slower shutter speed, and a blurring movement is introduced, giving the viewer no reason to doubt that this was a fast flowing stream, swirling and eddying as rivers do. Use a very slow shutter speed – several seconds or more –

and the rises and falls of the water during the exposure record as thin translucent mists.

For a waterfall or fountain the techniques are different. Falling water is not a smooth flowing liquid at all, but a fast moving succession of tiny droplets rushing past the eye so fast that they become a continuous stream. Freeze that motion with a very fast shutter speed, and the individual character of each droplet is recorded in an instant. Extend the exposure time, and the rushing droplets become a white blur, again leaving no one in any doubt as to the speed at which they are moving.

Light

Light in the landscape – whether with water or not – has to be appropriate to the effect the photographer wishes to create.

Inappropriate lighting destroys the harmony of a picture. A soft, gentle, peaceful still lake is not going to be suggested by strong side lighting. For that sort of shot, soft lighting is needed, either with the sun shining through a thin veil of cloud or with the picture taken early in the morning before the sun is very high in the sky. Low sun at dawn or dusk casts soft-edged shadows and as it is shining through a greater thickness of atmosphere and water vapour has a softer quality anyway. Early morning light is cooler than evening light.

For crisp sidelighting, later in the day is better; the air is usually drier and clearer, so shadows are harder-edged and contrast is higher. To accentuate the detail of rocks on a river bank, and get a silk-thread effect in rushing water, a late, clear summer afternoon is best, preferably with a few white clouds in the sky to lighten shadows just a touch.

For the classic water sunset there are two distinct approaches – the purist way and the modern bagful-of-filters way. The best sunsets are usually achieved when the barometer is rising, there are still some clouds, the air is still quite moist, and the sky detail is interesting.

Shooting straight into the evening sun – with a good lens of course – will produce a warm golden hue anyway, and some striking reflections even on relatively small stretches of water. It doesn't need to be a lake – a small pond with an interesting silhouette behind it bathed in a rich gold is a sure-fire winner.

Seasonal Changes

Water itself has little or no colour. Whatever colour it exhibits is really secondhand unless it happens to be laden with mud or chemicals. It reflects and transmits the colour from other areas. The colours which objects around water reflect on to the water itself are easily recognized even if their source is excluded from the composition – green/yellow foliage for spring, cold blue for winter, oranges for autumn and so on. That infinite variety of light and colours means that the same subject matter can be used month after month after month and yield quite different pictures every time.

Indeed the reflectant nature of water can be used to good effect, allowing seasonal influences well outside the camera's field of view to be included, enhancing and extending the picture content.

Duncan McEwan used a telephoto lens and high viewpoint for this striking composition using a mountain reflection.

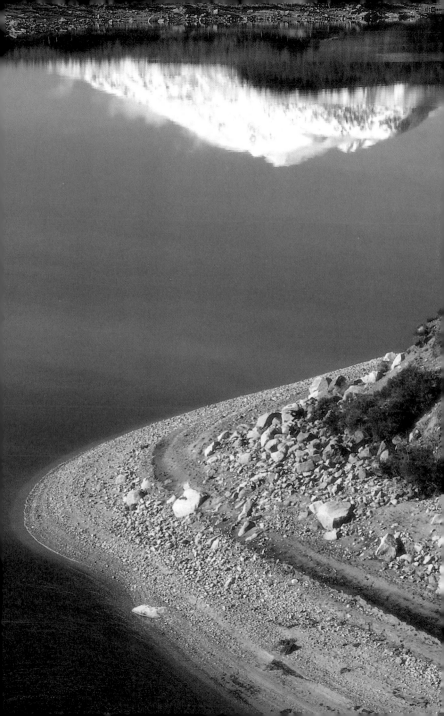

SINCE THE coast is such a favourite place for recreation and summer holidays it is little wonder that it figures largely in most people's photography. Man has always been fascinated by the sea, especially its enormously varied moods.

However, much of the appeal of the coast cannot be captured on film - aspects such as the smell of the sea, the sound of the waves, the calls of seabirds, the freshness of sea breezes. With these removed the photographer faces quite a challenge in trying to portray many coastal scenes adequately. Close-ups may convey the impression better.

The Foreshore

Between high and low water marks there lies a great wealth and variety of interesting subject matter. Some of this might lend itself to close-up treatment or it can be used to add foreground detail. A washed-up piece of seaweed could be a picture on its own or it could, with a well stopped down wide-angle lens, be just part of a much wider scene.

Being on a sandy shore as the tide ebbs will reveal many potential subjects in very natural and unspoiled condition - seashells or pebbles; pieces of

driftwood, smoothed and sculptured by the forces of nature; fronds of washed-up seaweed; pieces of rope or fishing nets. Some of these will prove more colourful if photographed while still wet.

Waves and Water

Waves breaking against a rocky shore or harbour wall, throwing water up into the air in a plume of white spray, can be a spectacular sight. To freeze the action, use a fast shutter speed, or to create a sense of movement and restlessness try quite slow ones.

A long lens will let you fill the frame with the action, or you could use the spray as an element of foreground interest. Watch the behaviour of the waves and note if there is any pattern that might let you predict a particularly spectacular one.

A low viewpoint can help to make breaking waves more impressive but it can be dangerous to go too close, and cameras don't benefit from a drenching with sea water. Protecting camera and lens with a polythene bag is always a wise precaution whenever there is sea spray about.

Water breaking on a beach is a safer option and can produce interesting patterns of pure white foam and froth. In this situation you will find a high viewpoint will probably be the best.

As the sea rhythmically advances and retreats it leaves a strip of wet sand. The more gentle the slope of the beach, the wider the strip will be. Its mirrorlike qualities will provide an opportunity to introduce reflections into a picture - reflections of the sky, children playing, people walking, wading birds looking for food.

Rocks, Sand and Weed

Much coastline is rocky, rather than sandy, but this does not mean it is any less interesting to the photographer, for here can be found seaweeds, rockpools and lichens as well as natural rock formations and patterns.

Seaweeds are most abundant on sheltered rocky shores because only here do they find firm enough anchorage to withstand the buffeting action of the waves. The colours of seaweeds will be best just after they have been exposed by the falling tide. Most of the weeds are an attractive olive brown but as they dry they become increasingly dark. When fronds are in their reproductive state the tips become a rich orange colour. If you find excessive reflections from wet seaweed a polarizing filter will help to remove them.

Fronds floating in water and just breaking the surface can form a very attractive foreground for seascapes. Likewise, at low tide the oarweeds (Laminaria sp) break the surface like mysterious arms

NATURAL DRAMA

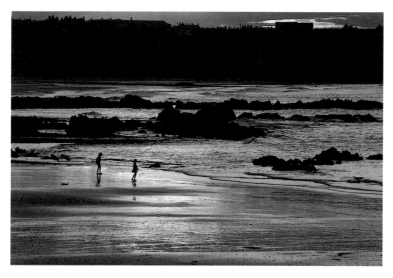

Left: the rich colours of a rocky shore in Inverness-shire, Scotland, seen with a 17mm lens and polarizer. Above: a wet strip of sand provides drama at sunset (200mm lens). Photographs by Duncan McEwan.

reaching out of the depths.

Photographing rock pools can be great fun and can be done without specialized close-up equipment, but you will need to watch for surface reflections. Choose a pool with a calm surface and find the camera angle that produces least reflection (around 40 degrees). Use a polarizing filter to eliminate any remaining reflections and you will now be able to see clearly into the pool, revealing its inhabitants - seaweeds, corals, sea anemonies, crabs and molluscs to name a few.

Rocks can be of considerable value in seashore landscapes but take time to look for the most interesting ones, either for their colour or their eroded shapes. Rocks encrusted with barnacles have a fine textural quality when side lit. Above high water mark the rocks may be covered with grey and bright orange lichens.

A shingle shore or one covered with large, smooth boulders can be worth a visit, preferably while the stones are still wet.

Good pattern pictures can be found where the receding tide has left sand in the form of ripples and ridges and often associated with these, the spaghetti-like casts of lugworms. Low-angled lighting will accentuate the detail.

95

Higher up the beach, the sand may support the growth of flowering plants and small dune formations can give a more varied form to the surface. One problem in this area can be blown sand and all your photographic equipment should be well-protected. Be particularly careful if you need to change films.

Open seascapes

One of the photographic problems of an empty seascape is that it usually takes much more than sea and sky to make a successful picture. An exception would be if the sea was very stormy or the sky displayed good cloud formations or a colourful sunset.

Avoid such emptiness by incorporating a strong foreground, or use an offshore island to break up a horizon. Consider carefully where to place the horizon - a sea won't look so empty if there isn't much of it.

Looking into the light will often reveal the sea as a glittering expanse and with careful exposure strong monochromatic shots can be produced.

Importance of the sky

The sky is important in all landscape work, but even more so with large areas of water because water gets its colour from the sky. With clear blue skies the sea will be blue, but clouds can introduce a varied tonal quality to the surface of gently moving water. In late evening, looking into a setting or recently set sun, the sea can become infused with yellows pinks, oranges or even reds.

Boats, People, Structures

One of the most obvious ways to strengthen a seascape and overcome an empty sea is to introduce a boat. In remote areas these may be few and far between but in larger estuaries, outside fishing ports, near sailing marinas or close to major shipping lanes it should prove easier. A boat need not be large in the frame to be effective but its shape is important - a yacht under sail is more interesting than one that is motoring.

Figures paddling in the sea, walking on the shore, or standing on land silhouetted against the sea, can provide useful focal points, as can the inclusion of seabirds.

Likewise, use man-made structures such as lighthouses, promenade railings, piers and offshore oil or gas rigs. At twilight some of these can be particularly interesting.

A 105mm telephoto minimized the foreground and emphasized distant islands in this busy seascape – directly against the light – for David Kilpatrick.

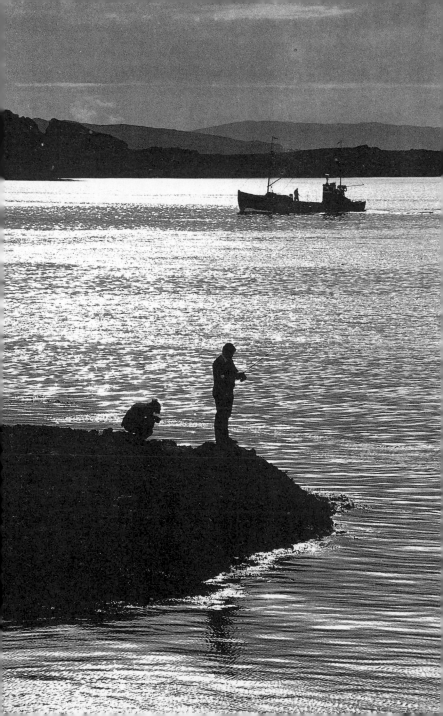

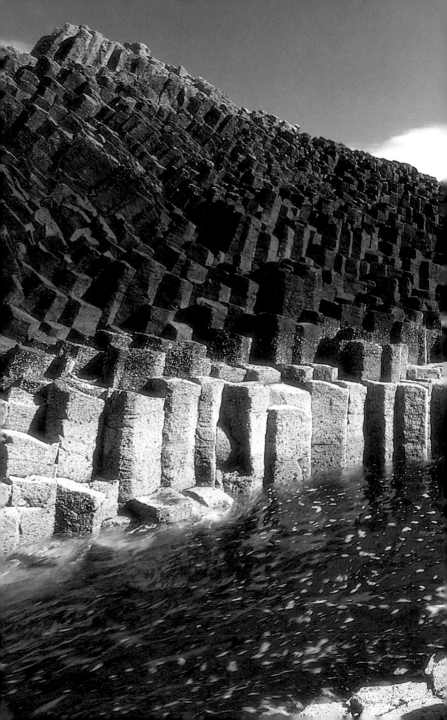

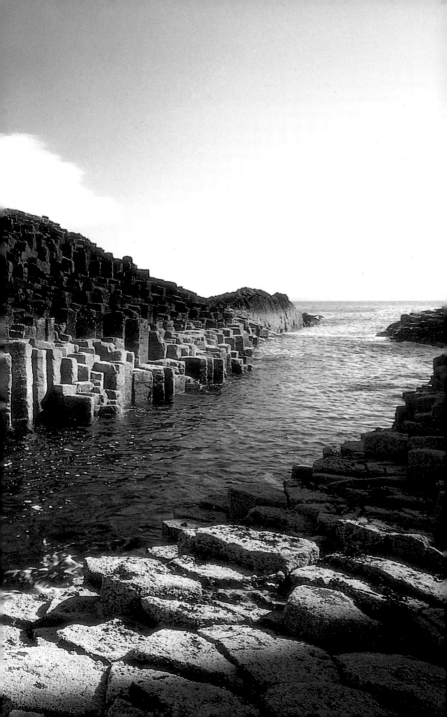

Filters and Exposure

Colour quality can be improved with an ultra-violet filter which cuts out excessively blue light and helps to eliminate haze. It will also protect the lens from sea spray.

A polarizing filter is highly recommended, not only for improving skies but for the way it can enhance the quality of the water. By removing surface reflections the sea may become bluer, and in shallow water a lovely turquoise colour with underwater sandbanks, rocks and algae revealed. A polarizer is also essential for rock pool photography. The sparkling quality of water is one of its most attractive properties, but a polarizer used carelessly can render it as a dull, lifeless expanse.

Use a graduated grey filter to reduce contrast if the sky is excessively bright, and if you wish to introduce colour then a graduated tobacco, orange or blue filter would do the trick.

Almost any lens will find application in seascape work. Telephotos will let you be more selective, to isolate offshore detail, and in stormy weather will keep you away from the worst of the spray. Use wide-angles when

Previous page: the pure drama of Staffa's basalt shores and cliffs, captured by Duncan McEwan in mid-summer.

you want to make the most of foreshore features.

On bright sunny days you may have to watch your exposure where there are large expanses of bright sand or sparkling water. The camera meter can be misled and to avoid underexposure give an extra half stop or so.

Sunsets

Sunsets are always difficult to resist for a whole host of reasons. Some regard them as a photographic cliché but the fact is that you never get two exactly alike.

There is no better place to view sunsets than from a west coast location. Light conditions change quickly and it is best to have viewpoints planned in advance. Remember that sea and sky alone might not be enough, and islands, headlands, boats, silhouetted figures or structures may be needed to strengthen the picture.

Composition

It is often much more difficult to compose pictures at the coast that at inland locations. At its worst, all the land can lie behind you, with only sea in front, and long straight coastlines do not lend themselves to easy composition. This is why areas with highly indented coastlines and many islands are easier to compose into strong images.

An anchor makes a strong foreground for this shot by Shirley Kilpatrick.

Viewpoints

Choice of viewpoint is so often the key to good composition. For shorelines, standing at the end of a bay is a good position without any sky.

Islands, apart from being subjects themselves, can also be used as solid platforms from which to view more prominent coastal landforms, provided they are not too far away.

Boats provide a more manoeuvrable viewpoint but they are less than ideal, unless movement caused by the sea and vibration from the engines can be overcome. Choppy conditions

with unpredictable movements might need 1/500 sec, whereas with more rhythmical action relatively slow speeds might be possible, provided you choose the correct moment to take the picture.

Vibration is best avoided by moving well away from the engines. Do not try to steady the camera against parts of the boat as these will transmit engine vibrations.

Foregrounds are always difficult, apart from parts of the boat itself - railings, lifebelts, figures, coils of rope. A wide-angle lens will let you include more of the boat.

A sloping horizon is always irritating, but especially so in seascapes where there is a more definite horizon. Holding a camera perfectly level aboard a pitching rolling boat is extremely difficult, unless the viewfinder has a grid screen when it's simply a case of keeping one of the horizontal lines in register with the horizon.

Views from inside caves

Photographing from inside a cave will provide a dark irregular frame to an interesting subject such as a setting sun, anchored boat or beach scene.

It is important to expose for the outside, by taking a reading before you enter or using a spotmeter from inside. Avoid including too much of the cave as

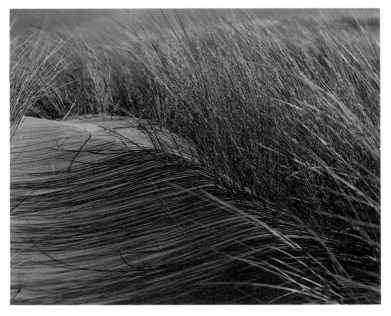

John Hannavy concentrated on the shadows and soft colours of dune grasses at Formby, Merseyside, for this 6 x 7cm transparency study.

the walls will appear black and lack any detail.

A natural rock arch can be used in the same way but will be much less contrasty, showing detail on the side facing the lens.

Cliffs

Cliffs can be difficult to photograph because viewpoints are limited. A shot from below will emphasize their height but you may have to get well back (for example at low tide) and use a wide-angle lens. Shooting from a boat might help but can pose

other problems.

Clifftop viewpoints can only be used to photograph other cliffs or where the cliff is curved or indented.

Lighting can be difficult as the cliff may only be interestingly lit for a short time each day.

Cliffs, however, form excellent vantage points from which to look down on the sea or to see a greater stretch of coastline. It will also be possible to exclude the sky and let you concentrate on the patterns, textures or lighting effects on the water or the coastline.

This classic shot of fly agaric fungi was taken by Duncan McEwan using a 50mm macro lens and two flash units plus reflector cards, using Fujichrome film.

LANDSCAPE AND nature are often regarded as different branches of photography. A view that included a large area of woodland would unhesitatingly be classed as a landscape, but we would regard a picture of a mossy hummock as being a nature shot. Yet there is a marked similarity, as both are pictures of plants adorning the surface of the earth. The only difference is one of scale. Plants are very much a part of the landscape and what we see depends on how closely we look.

Opportunities exist all year round for taking close-ups of plants. In spring, opening buds, unfolding fern fronds and spring flowers make ideal subjects. Flowering plants are available in all habitats during the summer and, as autumn advances, many will produce attractive fruits.

Autumn is the best time for fungi with woodlands and grasslands being particularly rich in species; the light is still good enough to allow an extended day. Don't ignore winter for this is a good time to concentrate on lichens, many mosses, tree bark patterns and textures, as well as plants encrusted with frost crystals. To begin with, don't go for subjects that are very small because the smaller the object the greater the technical problem.

103

This Novoflex bellows unit with a choice of lenses allows close focusing with any current or past 35mm SLR system

The right outfit

A 35mm SLR camera with a standard lens will not focus close enough to produce image sizes larger than about one tenth life size. Its use is therefore limited to plants larger than about 30cm (1ft) tall, and close-ups of small individual flowers will not be possible.

Zoom lenses often have a macro facility, allowing much closer focusing and producing useful image sizes of around a quarter life size. This should let you photograph plants of 10cm (4") in height.

Close-up Equipment

Production of larger image sizes requires additional equipment.

The simplest, lightest and least expensive is a close-up or supplementary lens which screws on to the front of a lens like a filter. Three different dioptre powers are commonly available (+1D, +2D, +3D). Unlike other methods of taking close-up's no exposure increase is necessary. Optically they may not quite match the quality produced by other close-up accessories, but they are well-suited for those who only want to take the occasional close-up with a minimum of problems.

Extending the distance between camera body and lens using extension tubes or bellows is a widely used method. The greater the extension, the greater the magnification.

Extension tubes come in sets of

three and can be used singly or in combination to give different magnifications. They can be used with any fixed focal length lens, but different lenses will require different extensions to produce the same magnification. A set of tubes allows an extension of 50mm and with a 50mm lens gives a 1:1 image size - and a light loss equivalent to 2 full stops. However, 50mm extension with a 100mm lens only gives a half life-size image. Automatic tubes, although more costly, are preferable to manual ones because they retain all automatic functions between lens and camera.

Tubes can be a bit of a fiddle but this is not a serious problem when photographing plants. Insects, however, won't necessarily wait while you try to find the correct tube combination.

Bellows give continuous rather than stepwise extension and can give greater magnifications, but they are not really suitable for working in the field as they are bulky, heavy and less robust.

The best way to photograph small detail is with a macro lens which gives continuous focusing from infinity down to a few inches. The most common focal lengths are 50mm and 100mm, but deciding which to buy is not always easy.

Both focal lengths are equally suitable for botanical photography. Small animals such as insects are easily disturbed and

the greater working distance of the 100mm would be an advantage. A 100 mm macro also makes an ideal lens for portraiture and general landscape work because the performance at long distances of these lenses is usually superb.

A wide-angle lens can often be used to good effect, giving a more landscape-like appearance. The subject will dominate the foreground, and the large area of environment included makes an ecologically more informative picture.

Camera supports

Producing larger image sizes will magnify movement in the subject and of the camera. The latter can be eliminated using a solid tripod. Look for a compromise between adequate rigidity and the weight you are prepared to carry around. Whatever you choose, it must be able to support the camera close to ground level. A tripod can be made more rigid by hanging a weight from the centre column, such as a canvas bag filled with stones or simply your camera bag. If the tripod legs are spread out on the ground try placing heavy objects on top to give added steadiness.

Mini-tripods are useful but are limited in their range of adjustment and may not be sufficiently rigid. It's still worth having one for occasions when you don't want to carry a large

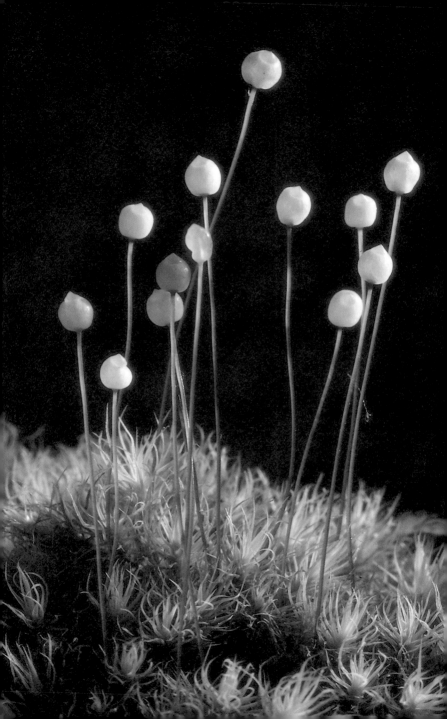

tripod.

A ground spike is another useful alternative for low ground work although its effectiveness depends on the type of ground. On stony ground it may be difficult to push in far enough, while on loose sand or wet peat it may be rather unsteady.

Flash and Reflectors

For close-up work, slow to medium speed film (ISO 50 - 100) is best but it can impose limitations when using natural light. Fast film, with its coarser grain and poorer definition, is not the ideal solution. It is easy to increase light levels with electronic flash, allowing the use of very small apertures even with slow film, and the short burst of light (1/1000 sec a shorter) will freeze any movement so there will be less need for a tripod.

Any kind of flashgun can be used and it need not be powerful as it will be used at such short distances from the subject. A manual flash will need to be calibrated by taking a series of shots with the flash at different distances from the subject and finding which gives the best exposure.

An auto flash with built in sensor does not work well in close-up situations but can be used in manual mode. The easiest system is a fully dedicated TTL flash with a camera with off-the-film flash metering. Simply choose an aperture and leave the system to work out the correct exposure.

Use the flash off-camera so that the subject is lit from an angle. Greater modelling, more surface texture and finer detail will be achieved. If the flash is held higher than the level of the subject it gives a better simulation of sunlight.

Single flash illumination can produce very harsh shadows but these can be lightened using a reflector or a second flashgun as a fill-in. To synchronize with the main light use a multi-outlet adaptor or a slave unit attached to the second flash. The fill-in effect can be controlled by placing muslin, neutral density gel or white plastic over the flash. Alternatively, move it further away or use the variable power switch if one is fitted.

Using flash off-camera may require a bracket to support camera and flashes, although its not as essential for botanical work as it is when photographing small, active animals. A simple one can be made from a piece of flat aluminium bar and a couple of ball and socket flash heads. The camera attaches to the centre of

Left: Duncan McEwan used a twin electronic flash set-up for this close-up of fruiting bodies of moss, taken with a 50mm macro lens set at ƒ22 and mounted on a ground-level tripod.

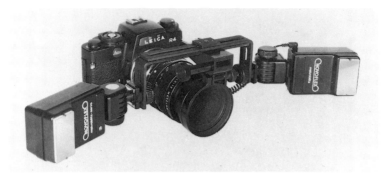

A proprietary twin flash bar from Novoflex to fit 35mm systems.

the bar with one flash on either side. The main light should shine downwards and obliquely across the subject but the fill-in is best kept around camera level. Regularly check that the flashes are properly angled towards the subject, as the correct angle will vary with the distance from the subject.

With flash you cannot see the lighting effect being created, and backgrounds often turn out black. Having the background nearer will overcome this, or you can use a third flash purely to light the background.

When photographing plants it is often better to support the flashes on small tripods or long ground spikes rather than on a bracket. This lets you move the lights around as you would in a studio. Alternatively, put the camera on a tripod and hand-hold the flashes.

Multi-flash set-ups can, with care and practice, produce fairly natural looking results but it rarely equals the quality of natural light. Mixing daylight and flash, however, is a technique well worth experimenting with.

Reflectors are extremely valuable accessories, whether with flash or natural light. Their precise effect cannot be foreseen when using flash, but with daylight you can produce very carefully controlled and balanced illumination. A piece of white card, white polystyrene sheet, or crumpled aluminium foil will all work well giving different degrees of reflection. Control can also be achieved by altering the distance between reflector and subject.

The right subject

Finding good subjects is not difficult if you make a conscious effort to switch your attention from distant horizons to your immediate surroundings. Look for easy subjects to start off with.

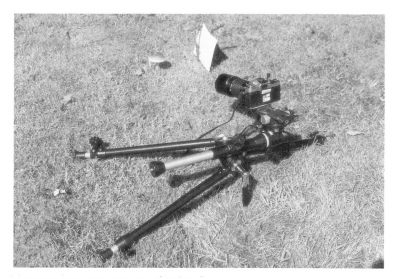

McEwan set up his camera with a 100mm macro lens and a small reflector card, using a Baby Benbo tripod (top). The result – from a colour original – is shown bottom.

Even an overcast day, with soft fully detailed lighting, can benefit from a reflector. Cross-leaved heath photographed with a 100mm macro, Fujichrome film; by Duncan McEwan.

For example, fungi are rigid and not very tall so they are relatively unaffected by wind compared with thin-stemmed flowering plants.

Whatever the subject, it is well worth spending time selecting the best specimens available. Time spent looking and assessing is time well spent. Look for undamaged specimens, or ones which form a pictorially pleasing group, or maybe a specimen showing more than one stage of development, such as flower and fruit. If it is windy, look for a subject in a more sheltered location. Backgrounds and surroundings can be as important as the subject itself and should be carefully studied, as well as possible viewpoints.

"Gardening"

Quite often you may find an attractive subject spoiled by untidy surroundings - for example broken twigs, dead leaves, light coloured stones. These can be carefully removed in order to tidy-up the scene, a process called "gardening" or "landscaping". Use forceps if necessary so that least disturbance is caused. Fine pointed scissors are useful for snipping off unwanted blades of grass, but don't leave cut ends visible. Sometimes having removed something distracting you may need to replace it with something less so. Spotting

distracting elements in the background is made much easier by using the stop-down button on your camera.

Creating tidier surroundings may give a more pleasing result, but if overdone can lead to loss of information about the habitat. For example, leaves surrounding a woodland fungus gives a clue to the identity of associated trees.

At all times, show respect for the welfare of the subject and its surroundings. Do not uproot flowering plants. Be careful when you are "gardening", and always avoid unnecessary trampling which damages other plants.

Isolating the subject

Ideally you want your subject to stand out from the background rather than being confused or merging with it. Have the subject in sharp focus but with the background completely out-of-focus is what to aim for. Avoid out-of-focus foregrounds unless you want special pictorial effects. Focus carefully by moving the camera backwards and forwards until the subject comes sharp - on a tripod, this is best done using a focussing rack.

Choice of aperture is the best means of achieving this, the smaller the aperture the greater the depth of field. Too small an aperture can give backgrounds that show too much detail and the best policy is to use one that just gives enough depth of field to

cover the subject. Whereas a close-up of a flower might require $f22$ to get everything sharp, a picture of the whole plant might only need $f8$. Likewise, flat subjects such as broom pods, lying in the same plane as the camera, may be adequately covered by $f5.6$, whereas the rounded shape of a toadstool could need $f16$.

Viewpoint is also a means of controlling the background. A low camera angle might place flowers against the sky or other distant background, whereas a higher viewpoint creates a nearer background and consistently less separation.

Differential lighting can help separate a subject from it's background. Backlighting or rim lighting can be very effective, as can a little extra light on the subject so that it appears brighter than the background.

For complete control of background details you can use a painted card or canvas, with areas of smudged pastel colours, but avoid uniformly coloured ones as they look too artificial. A false background can be set up using bark, fern fronds, pieces of rock etc, but always ensure it is appropriate for the subject so that it looks authentic.

Exposure and movement

Getting an acceptable combination of aperture and shutter speed is not always easy if

Some subjects aren't affected by the wind (Shirley Kilpatrick).

you opt for natural lighting. Subject movement will necessitate a fast shutter speed, although how fast depends on the degree of movement and how close the subject is. Using too fast a shutter speed may result in too large an aperture giving insufficient depth of field.

There are ways of minimizing subject movement such as shielding the subject from the wind with rucksack, camera bag, special windshield or even your own body. A waving stem can be staked with a knitting needle and twist tie. Because air movement is never constant for long, try to time your exposure to moments of comparative calmness, and you can get away with using quite slow shutter speeds.

11: FIGURES AND BUILDINGS

WHILE THE empty landscape may have its attractions – and there are many – there is a lot to be said for the 'man and the environment' approach to landscape photography. That is not to say that every landscape picture must be controversial – far from it – but there is a wealth of picture potential to be found in relating people to the landscape, or relating buildings to their surrounding landscape.

People

At the very simplest level, people add human interest. They become a focal point within the picture, and a focus for our further direction within the geometry of the image. For instance, we are likely to direct our attention towards whatever the people in the picture are looking at, so careful direction of them – or suitable camera position if we cannot direct them – will further direct the attention of anyone looking at the finished picture.

More importantly, perhaps, they add scale to the picture. Of course that can be a false scale, as we know the way scale/perspective can be manipulated by the camera, but they can add a sense of scale.

People also add colour – and that can be a very powerful directional device in a monochromatic landscape – adding a strong focal point to

draw the viewer into the frame.

Equally important to bear in mind, and for all the same reasons, is the simple truth that figures inappropriately placed within the landscape can also destroy it. They can disrupt the reading of the picture, confuse the message and generally turn an otherwise pleasing composition into a total mess.

Scale & Depth

In earlier chapters mention has been made of the exaggeration of perspective that is possible with wide and ultra wide lenses, and how the use of maximum depth of field coupled with perspective distortion can enhance the apparent depth within a picture. While the more normal exploitation of this technique would be with rocks, close-up natural detail and so on, it can equally well be created with people. A wide-angle lens and good depth of field, with two figures, can create the beginnings of a strong visual movement into the picture by using the natural experience of scale; a person closer to us appears larger than a person further away. Use the effect created by the wide-angle lens to enhance this.

Colour & Focal Points

However, there is an inherent risk, in trying this without care and forethought. For example, if

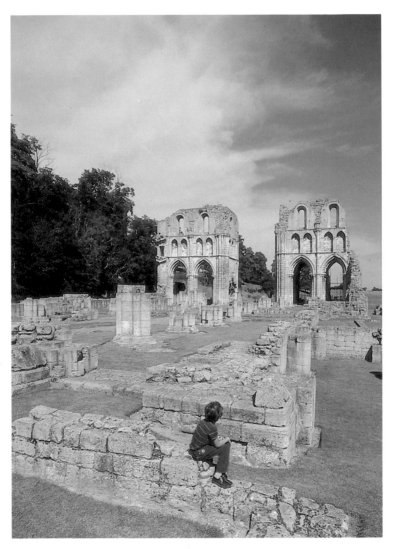

Outdoor clothing is often fairly colourful and can add to the perspective in an otherwise neutral scene. Be careful to avoid too dominant a foreground figure. Photograph by David Kilpatrick.

one of your figures is dressed in light clothes and the other in dark, you must take great care in the relative placings of the figures. A light figure has greater visual attraction in a normally lit scene than a dark figure. If the light figure is in the foreground, the dark figure will not exert much visual pull in the middle distance, so will be overlooked. The light foreground figure, rather than drawing the viewer into the image, will act as a visual barrier and effectively block movement.

Given these circumstances the darker figure should be closer to the camera, with the lighter figure in the middle distance drawing the viewer into the body of the landscape.

The relative visual strengths of colours can have the same effect. We are naturally drawn to bright colours – and particularly to colours in the yellow/orange/red end of the spectrum, so bright clothing within that sector of the colour circle should not be allowed to dominate the foreground. If it does so, then movement into the picture will be considerably restricted.

Darkening of such colours will largely overcome this visual barrier – perhaps by placing the foreground figure in shadow or semi shadow to reduce the brightness and therefore the attraction of the coloured clothing. Natural visual movement is from dark to light – never the other way around under normal daylight. Perhaps the worst block to visual movement into a picture is a brightly coloured out of focus area. It is almost impossible to move past that and get into the smaller detail of a landscape.

Taking Direction

If a figure in the foreground of a picture is clearly looking at something in the middle distance, the direction suggested by that figure will be picked up and followed by the viewer. It takes a particularly confident photographer to position a figure looking out of the frame rather than into it. Looking into the frame, the figure is seen as being interested in the landscape. Looking out of the frame, the figure is seen as trying to escape from or ignore the environment in which he or she is placed.

The use of such figures in the foreground therefore fulfils several functions at the same time. An appropriately placed figure has a compositional function in itself – a breaking up of the uniformity of the frame of the picture – and perhaps with trees, fencing, etc, forming an unusually shaped frame for the landscape viewed through it. There is also the directorial function, suggesting a particular visual movement.

Thirdly, there is the suggestion of familiarity – of circumstances with which the viewer can readily identify. Fourthly, and often most

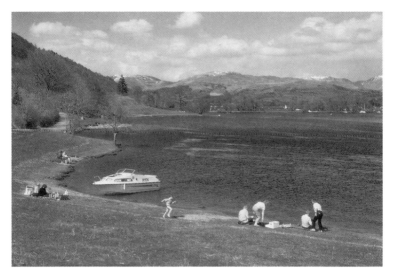

Figures and their activities can be entirely appropriate in a landscape scene where the landscape itself is part of the world of leisure. Just make sure the scale and emphasis is correct. By David Kilpatrick.

usefully, the large mass of that foreground figure can be used to obscure detail which would not fit in with the predetermined purpose of the picture – allowing electricity pylons, cooling towers or any one of a thousand other blots on the landscape to be obscured.

Relevance

Of course if the whole point of the image is to suggest that this is a completely empty landscape, that men don't live here, the use of any figures at all might be wholly inappropriate. A figure or group of figures should only be included in a picture when they are essential to the transmission of whatever idea is behind the picture. Otherwise their accidental intrusion into the landscape may be quite counter-productive.

Given the familiarity of the human form, its visual attraction should never be under-estimated. Your viewers will naturally and quickly move towards figures in a picture. If in doing so they miss essential ingredients, then they fail to read the picture as you intended. Sometimes it is worth shooting a scene two ways – with and without figures – or adjusting emphasis through composition.

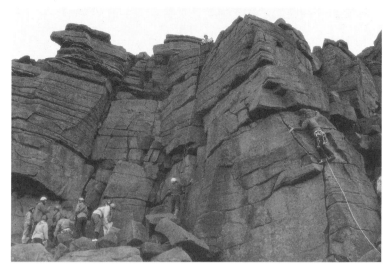

Outdoor activities add colour to the wilder parts of the countryside, where people go to enjoy adventure sports. They provide good shots even from a distance. David Kilpatrick.

Activities

There is a fine line to be drawn between landscape photography and any one of a number of other arbitrarily defined branches of photography. When does a landscape picture cease to be a landscape picture and become, say, a sports picture? While an empty snow-covered hillside is clearly a landscape, how do we define a snow covered hillside with a group of skiers? Is it sport or is it landscape? And does it matter?

In one context, the skiers could be an element within a landscape, while in another the landscape merely becomes a backdrop to a separate activity.

Skiers on a distant slope, climbers on a distant rock and so on can all be a useful end to the visual movement into a picture. If they are sufficiently distanced from the camera to place them clearly within the landscape rather than in front of it, they can strengthen the visual interest while still allowing the natural contours of the landscape and the interplay between light and those contours to be the central purpose of the image.

On the whole, it should be pretty clear when a figure 'fits' and when it does not.

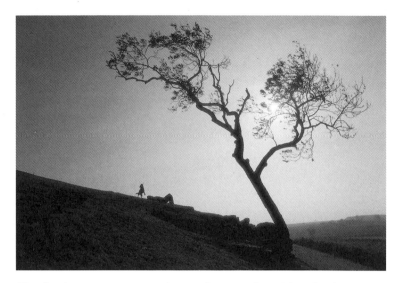

Simple elements – a man, a dog, and a tree. Contre-jour landscapes demand bold shapes, and work well in both monochrome and colour. Photograph by David Kilpatrick.

Silhouettes

Figures in a contre-jour picture must follow broadly the same rules. Here, though, the likelihood of the figure dominating is reduced by the visual strength and impact of the sun, a vivid sunset, a striking cloud effect and so on. The figure serves a useful and often vital scale and perspective function while, because it is without detail except in outline, the risk of its dominating is limited.

In such compositions keep the silhouette shape obvious but simple so that there is little to distract the viewer for too long.

You may be able to direct the person in the scene to move an arm or leg, create a better shape or perhaps move position slightly to a more interesting focal point.

Buildings

The Victorian folly-builders had an interesting approach to landscape. It was the first half of the nineteenth century which saw the beginnings of today's understanding and appreciation of landscape – but to the Victorians that was overlaid with a romantic idea of what a landscape should look like. The typical Victorian landscape in the

Follies enhance the scene everywhere... photograph by David Kilpatrick.

finest romantic tradition included rocky outcrops capped with ruined and overgrown castles, the skeleton outlines of weed-encrusted Gothic abbeys and so on. To them that was the natural landscape and where ruined castles didn't already exist, they built one! Thus fine hills like Mow Cop in Cheshire (and many others) were adorned with customized ruins less than a century and a half ago.

While we clearly have a longing for totally unspoilt countryside, we still retain that Victorian romantic attraction to ruins – they seem right for the landscape in a way which power

stations, factories and mills do not.

In that respect we are no different to any other generation. To us bridges, castles, abbeys and so on are so liberally scattered across the countryside that they are acceptable. They are also built of local materials, so they already have a natural harmony with their surroundings which concrete cooling towers will never achieve.

Just as with figures, the use of buildings, or indeed any other man-made feature, can serve a variety of purposes. Buildings in the landscape can be approached from either a sympathetic or unsympathetic standpoint. The romantic ideal of the castle, abbey or monument as an integral feature of a landscape is one approach – but the insensitive ruination of a landscape by the erection of inappropriate structures can be portrayed just as powerfully in a photograph. Indeed, in the latter case, there is a strong argument for breaking the rules and strengthening the point by photographing such structures in a way which exaggerates their dominance of their surroundings.

The combination of carefully selected camera position, a long lens and the right light can make power station cooling towers apparently overwhelm a peaceful, romantic and natural hamlet of thatched cottages set amidst rolling green fields.

119

Equally, the use of a wide angle lens, a lot of foliage and a camera position well removed from a romantic ruined castle, can set that ruin as an integral part of a wholly acceptable and apparently totally natural landscape. Neither is a completely accurate or honest reading of the scene, but each makes its point very strongly.

Lighting for Architecture

There are different lighting requirements for buildings as the subject-matter in a picture and buildings as elements within the landscape. Indeed, within the landscape, lighting requirements are controlled and dictated by the emphasis required by the photographer. Strong side lighting for instance, can give a building greater strength within a landscape than near direct frontal lighting. The use of shadows cast by clouds in the foreground while the building is sunlit emphasizes the building, while the reverse plays down its importance. The same lighting on landscape and building – whether it be direct or oblique, imparts roughly the same sort of visual strength to both.

The time of day, the time of year and the quality of the light can all affect the strength of the building within the picture. Given our sympathy towards the soft yellows and greens of late spring and early summer, and the softening effect of foliage, a building photographed from a considerable distance seems more settled within its environment under these conditions than it does, say, in the middle of winter when there are no leaves on the trees. Add snow to that set of conditions, and the dark sombre solid mass of a castle takes on a forbidding and distinctly unnatural guise.

As with people in the landscape, the rôle of the building must be clearly understood in the context of whatever composition you are setting up. If the building is the dominant element, then its relationship to its surroundings – the central purpose of such a picture – will direct lighting conditions, time of day, camera position and lens focal length.

If it is just one element within a wider landscape composition, then while those same relationships are important, it may be that achieving a combination of conditions which will avoid letting the building dominate which rules the day.

Either way, the impact of the building within its landscape should never be ignored as that will ultimately control the success or failure of the picture.

The building in this quiet scene at Allonby on the Solway Firth gives so many clues to the date and feel of the place that it is essential, though subordinate to the dyke. Photograph by Shirley Kilpatrick.

12: THE URBAN LANDSCAPE

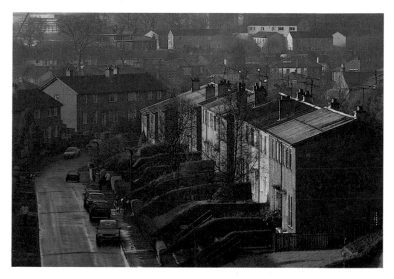

Left: if this was a path beneath trees it would be landscape, but is it really an architectural study? Above: an older face of the city environment. Photographs by Duncan McEwan.

TO MOST photographers mention of the word "landscape" immediately conjures up mental images of fields, mountains, moorlands, trees and rivers – in short, pictures of the countryside. Yet within our larger towns and cities there also exists an alternative landscape of rather a different kind. This landscape has been created by man and consists of houses, office blocks, multi-storey flats, factories, roads, railways and so on. Perhaps it isn't as attractive as the countryside but that's no reason for ignoring the photographic opportunities of our built-up areas.

Many people feel much less comfortable when photographing in urban areas compared with the countryside, particularly in the less desirable, derelict or industrial parts. This is quite understandable, and if fear of mugging or theft of valuable equipment is what puts you off exploring this landscape, then a good idea is to go with a friend or two, at least until you gain confidence and get to know an area well. With such possibilities in mind it is advisable to keep equipment to a minimum. Carry one body, a 24-35mm zoom and a 70-210 zoom and you will find these will cover most situations.

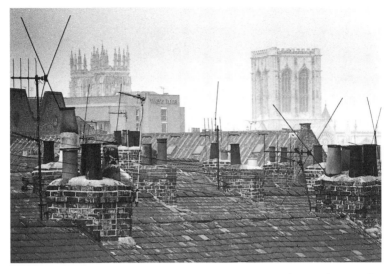

In the city of York, Shirley Kilpatrick saw the potential in rooftops and aerials to dehumanize the view (above). David Kilpatrick waited for people to appear in his terraced street scene, right.

The zooms are ideal because choice of viewpoint is often very restricted, not to mention the problems of intervening lamp standards, overhead wires or vehicles.

In many ways urban photography has much in common with that in rural areas and so much of what has been written in the three previous articles in this series will be equally applicable and need not be restated in detail.

Suffice to stress that good lighting and strong compositions are vital considerations. Add to that the value of pattern, texture, colour and you have all the ingredients for successful landscapes in either environment.

Human scale

In rural landscape work figures may intrude on the natural beauty of the scene, particularly in the more wild and remote areas. On the other hand, in urban scenes, the human figure is such a key part of city life that a picture will quite likely appear incomplete without the presence of people. There are all sorts of people to animate such a scene – business men, workmen, shoppers, policemen, street vendors and sightseers to name but a few.

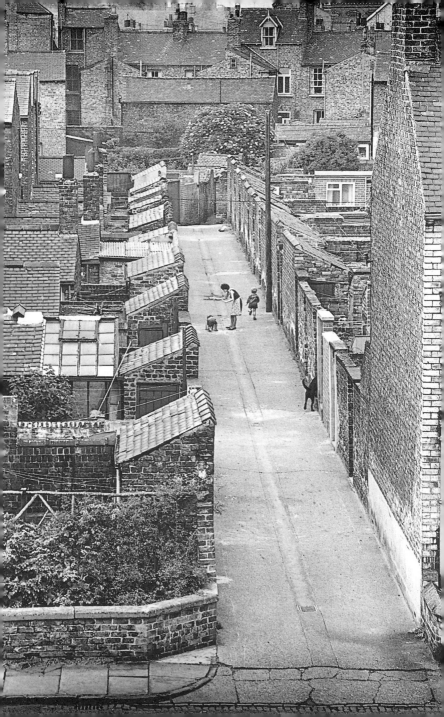

A small figure in a dramatic vista of concrete – life in a city planned for functional qualities rather than visual appeal. For the photographer, the stark lines make composition simpler. By Shirley Kilpatrick.

The relationship of man with his environment is probably easier to portray in a city than in the countryside, although waiting for the right people to complete the scene may require patience. The graffiti at the base of the modern tower block say something about vandalism in our cities but then the story would have been incomplete without the appropriate figures. Lots of people pass by, young and old, but those that seem to fit best

Previous page: the graffiti and impersonal development of modern city centres make a potent symbol. Duncan McEwan.

have to look right – perhaps because they represent the age group most likely to have perpetrated acts of vandalism.

Prominent people

Cities, are busy places and you may choose to use figures in a more prominent way. In a railway station scene figures can occupy the foreground area rather than being focal points away in the distance. It's easy to recognize the feelings of frustration and boredom that often typify major travel centres. Background trains and overhead destination boards help to

LOOKING DOWN

Some cities can best be seen as landscapes from a high viewpoint – a sea of buildings, or of lights at night. Find a tower block with a publically accessible viewpoint. Photographs by David Kilpatrick.

complete the atmosphere; urban scenes like this can tell a story.

Contrast in architectural styles can form the basis of many good urban landscapes as can contrast of building materials such as concrete and natural stone.

The derelict building adjacent to more prosperous and well-kept properties is always worth keeping a look out for. The inclusion of a small section of broken down brick wall in the photograph on the previous spread contrasts well with the brightly coloured, graffiti-splattered facade of the multi-storey. A telephoto lens helps isolate the subject from the sky.

The docks, Greenock, photographed by Duncan McEwan using a 24-35mm zoom lens at dusk.

Industrial scenes

Subjects of an industrial nature are found in all urban areas and are well worth investigation. Low-angled lighting will accentuate the corrugated iron and other structural details of old factories in close-up, while light-coloured buildings and modern structures from a distance stand out well against the sky.

Access to industrial areas is not always easy and you might well have to be content photographing from outside perimeter fences. Even this could pose problems and there are instances of amateur photographers being apprehended for questioning when found photographing petro-chemical plants, or security-sensitive areas such as airports, docklands and so on. To avoid possible embarrassment it might be worth making some enquiries in advance.

13: THE PROFESSIONAL VIEW

The requirements of professional photography are very different from those of the hobby photographer. Here, John Hannavy has photographed peat-cutting on the Isle of Skye as a pure record shot using 6 x 6cm film for book and magazine illustration.

FEW PHOTOGRAPHERS make a living exclusively from landscape photography, but many find that professional landscape work is both personally satisfying and profitable.

The markets for landscape work are obvious – calendars, greetings cards, book and magazine illustration, jigsaw puzzles and so on. However those markets are not particularly large – a calendar, for instance, uses only thirteen pictures per year, and perhaps fewer than half of them are pure landscape. For that small final selection, the publishers may look at several

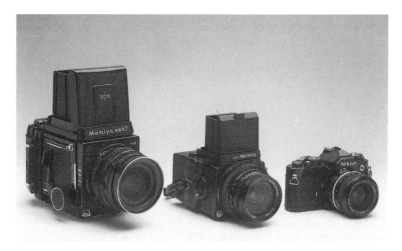

Left – two specialized landscape cameras. The Fujica Wide 60 takes 6 x 4.5cm format slides, while the G617 produces wide-angle 6 x 17cm panoramic views. Above: 6 x 7 Mamiya, 6 x 4.5 Bronica and 35mm Nikon cameras show the difference in bulk between truly professional, general freelance and mainly amateur formats.

dozen images from each of at least as many photographers.

To break into this semi-exclusive market professionally, personal style is very important. If you produce the same sort of pictures as a hundred other photographers, no one is going to feel particularly drawn to yours. Developing a personal style, using strong picture geometry to give your pictures immediate attraction, and producing truly original interpretations of well known views are essential ingredients of success.

Marketing the material yourself is difficult – for the first few years – until you have built up a

reputation, a list of contacts, and a portfolio of good published work. For that reason many photographers operate through picture libraries. Libraries have all the right contacts, but they also have several dozen or even several hundred other photographers on their books. So your pictures are going to have to be good to get over the first hurdle – being accepted by the library.

Once in the library, they will be circulated all the time in

Overleaf – a 5 x 4 view from John Hannavy's picture library.

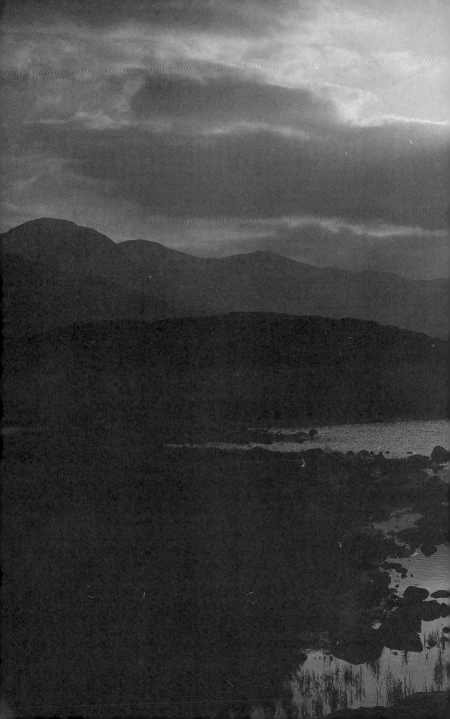

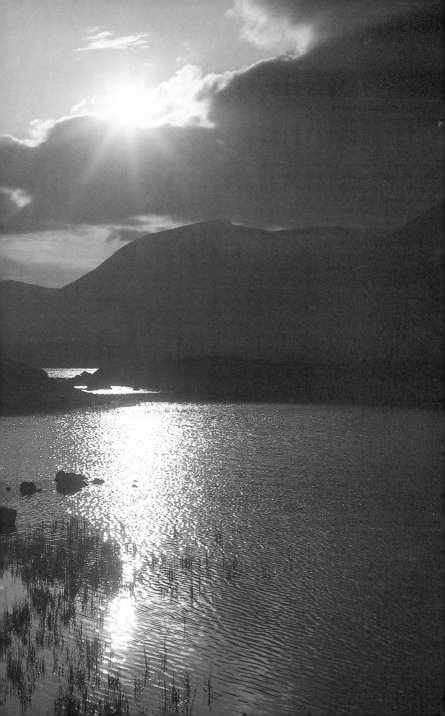

response to requests from publishers, and many amateur and semi-professionals make quite substantial sums of money out their work. The library usually takes half of the gross monies earned as their fee for marketing the material on your behalf.

Knowing the markets is essential if your pictures are going to have any chance of success. Looking at the sort of magazines, calendars and so on which might use your work in the future is essential preliminary research. There is no point in producing excellent work that is of a format, shape or style which no one wishes to buy.

Format

It has to be said at the outset that the calendar/greetings card/chocolate box/puzzle market is almost totally closed to the 35mm worker. This is an historical exclusion rather than a realistic one – although there are additional problems of cleanliness and so on when reproducing from very small transparencies.

Rollfilm transparencies 6cm sq and larger are usually welcome by most publishers, although it is still true that a good 'big un' – 4 x 5 or even 10 x 8 – will almost always outsell a good 'little un'. 6 x 6, 6 x 7, 6 x 8, 6 x 9 and the sheet film sizes are all welcomed by calendar publishers if the visual content is good enough.

Material

Most publishers insist on reversal stock; their colour scanners work more easily, and their staff are more used to working with transparencies than prints. Transparencies have a wider tonal range than prints, and that makes for richer shadows, cleaner highlights and so on. Additionally, as prints have been through an additional optical system – the enlarger – they tend to be slightly less sharp than transparencies, although this problem is only apparent if the print is being reproduced much larger than it's own original size.

Markets for 35mm

While photographic magazines are geared up to working from 35mm originals, many other glossy magazines are still reluctant to do so, although the geographic and news magazines are users of 35mm almost exclusively. Travel magazines will accept any format from 35mm upwards as long as the quality is up to scratch.

Many markets are completely closed to non-commissioned 35mm work. However in monochrome – where the editor doesn't know the format used – material is judged on the quality of the image and the print supplied. Here the 35mm market is quite buoyant and there are many opportunities open.

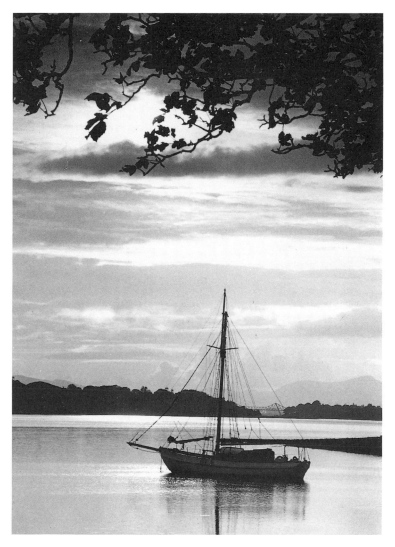

In black and white, 35mm work is perfectly acceptable to many publications. This 35mm shot by David Kilpatrick has been reproduced often by magazines right up to full page size.

Rollfilm & larger

It is worth stressing that no magazine – with the possible exception of low payers like many of the county magazines – are interested in seeing a single good transparency. The photographer who has produced the occasional good picture is only likely to see it in print if prepared to accept a pathetically low fee.

Many county magazines pay ridiculously low cover fees. On the other hand, most major magazines pay £50 to £200 for a good cover; £50 is normal, with £100 not unusual.

The good landscape photographer working in larger formats has a much less restricted market at which to aim. Travel books, magazines, guide books, calendars, postcards, greetings cards and a thousand other uses which the picture library knows about and the average photographer wouldn't even dream of, have a constant need for good quality and visually dynamic pictures.

The prestige markets are harder to break into – as everyone is trying them – and are often less lucrative. Background images for hotel brochures and so on may not give your photography the 'up front' profile you would like, but they pay well, quickly and regularly. That marks out clearly the difference between the amateur wishing to make a hobby

pay for itself, and the professional needing to pay the mortgage. The professional is less concerned about the glamourous image of photography – and the use of photographs as works of art. The professional has to make a certain amount of money per year. The amateur is delighted to see work in print. Indeed, some publishers have different scales of fees for professional and non-professional work. So if photography is not your main source of income, keep that fact to yourself. Broadcasting the fact could cost you earnings.

Rules & Regulations

It is also worth pointing out that photographers do not have an automatic right to make money out of photographing whatever they like wherever they like. If you are in a public place you may take photographs to your heart's content, but if you are on private land, the owners of that land have every right to place quite severe restrictions on your freedom of movement as far as commercial photography is concerned.

The most obvious one is a restriction on the use of tripods. Many landowners and owners of stately homes work on the principle that the professional uses a large format camera with a tripod, the amateur does not. Therefore by banning the use of tripods, they seek to exclude professionals from exploiting

what is, after all, private property. If the ban extends only to the use of tripods, then hand held architectural and landscape photography may indeed be tolerated if not exactly encouraged.

Some locations have a total ban on photography for commercial purposes without authority, and sell permits. Buying a ticket to enter a private estate, an English Heritage or National Trust property, or indeed any other privately controlled location, is a legal acceptance of their terms – even if you do not know what those terms are!

The onus is upon the visitor to find out! If you continue to take pictures, that may imply that you are an amateur taking pictures for private use only. If you take a brilliant picture without meeting their commercial photography requirements, you do not have the right to sell it. While very few owners would do anything about it – as your picture in print publicizes their property – their right to do so remains.

A particular problem, and an irritation to most photographers, is to arrive at a location, find that a permit is needed, and be told that it has to be applied for seven days in advance from a PO box in London. While such information might have been uncovered in a good recce for a fashion/product/commercial shoot, the landscape photographer turning up on holiday with no prior knowledge

of the rules and in no position to organize a permit is at a bit of a disadvantage.

It should, however, be the sort of problem you hit once only. If you find that one property owned by a particular organization requires a permit, you can be sure all their other properties will also require one. With that knowledge, advance planning can be more effective in the future.

Market Demands

The landscape photographer who has studied the market is likely to reap much richer rewards than one who hasn't. Shooting pictures with market demands in mind is essential. Most calendars, for instance, require landscape format pictures. Most magazines use full bleed vertical images with a space left at the top for the magazine title. That simple piece of information may require either (a) a square picture which can be cropped two ways or (b) both a landscape and a vertical version of the shot to be taken.

Activities (outdoor) 117
Apertures 12
Architecture 119, 122
Autumn 74

Beach 92
Bean bag 105
Bellows units 104
Black and white 56-69, 137
Buildings 118

Calendars 131
Cameras 10, 132-133
Caves 101
Cliffs 102
Close-up lenses 104
Close-ups 104
Colour 45, 49, 51, 113
Colour temperature 41, 44, 48, 81
Compass 10
Composition 28-36, 100
Contrast 22, 24, 65
Contre-jour 118

Dawn 80
Depth of field 20
Dusk 80

Equipment 8, 9, 13, 104
Exposure 65, 80, 82, 88, 100, 112
Extension tubes 105

Film 18, 22, 53, 59, 136
Filters 17, 26, 48, 52, 64-68, 77, 81, 100
Flash 107
Focusing 20, 21
Fog 77
Formats 10, 59, 136
Formats 12, 37
Freelancing 131, 136
Fungi 101

Horizon 30

Industry	130
Infra-red	61
Lenses	12, 36
Light	9, 39-44, 85, 90, 120
Light metering	20, 21, 22, 41, 82
Macro	104
Meter patterns	21
Mist	77
Mosses and lichens	101
Natural history	103-112
Orange filter	64, 73
People	96, 113, 124, 128
Perspective	84, 113
Planning	9
Polarizer	17, 85
Polaroid materials	12, 18, 63
Printing	62, 68
Processing	63
Professional work	131-139
Rain	74
Red filter	64
Reflections	85, 87
Reflectors	107-110
Restrictions	138
Rollfilm	138
Sea	92-102, 96
Sepia toning	58
Shore	92, 93
Shutter	24
Silhouettes	118
Sky	96
Snow	74, 77
Snow scenes	44
Spirit level	19
Spring	70
Storms	80

INDEX

Summer 73
Sunsets 44, 81, 100

Tripod 15, 17, 19, 106

Urban scenes 122-130

View camera 12
Viewpoints 101

Water 83, 89, 93
Wide-angles 14, 36, 84
Wind 80
Winter 74

Yellow filter 64
Yellow-green filter 65

Zooms 123

LOCATIONS OF PHOTOGRAPHS

Throughout this book, the photographs have been credited with the photographer's name. For the benefit of readers, the locations of the photographs are given below where these are not mentioned in the captions and data is available.

COVER Loch Linnhe and Ben Nevis, Scotland, by Duncan McEwan
Page 6 Scotland, West (no precise information available)
Page 11 Loch Chon, Aberfoyle, Central Scotland, south end
Page 19 Loch Eil, Scotland
Page 23 Haigh Woods, Wigan, Greater Manchester, England
Page 25 Rockley, Nottinghamshire, England
Page 27 Chatsworth, Derbyshire, England
Page 29 Bottom: Morthen Common, South Yorkshire, England
Page 30 Berwickshire coast, Scotland
Page 31 Castle Stalker, Loch Linnhe, Argyll, Scotland
Page 32 Housesteads, Hadrian's Wall, Northumberland, England
Page 33 Watendlath village, Cumbria, England
Page 35 Glencoe, Argyll, Scotland
Page 36 Formby, Merseyside, England

LOCATIONS contd.

Page 37 Glencoe, Argyll, Scotland
Page 42 Roshven, West Inverness-shire, Scotland
Page 44 Loch Linnhe, Scotland
Page 50 Glen Nevis, Scotland
Page 51 Loch Sunart, Scotland
Page 54 Sheldaig, Scotland
Page 57 Bassenthwaite, Cumbria, England
Page 59 Castle Stalker, Loch Linnhe, Argyll, Scotland
Page 60 No details supplied
Page 66 Doddington, near Lincoln, England
Page 70 Wray, Lake Windermere, Cumbria, England
Page 72 Listerdale Woods, Wickersley, South Yorkshire, England
Page 75 Top: Glen Feshie, Scotland
 Bottom: Glen Morriston, Scotland
Page 83 High Force, River Tees, Middleton-in-Teesdale, Durham,
 England.
Page 85 Loch Achray, Central Scotland
Page 86 The Red Burn & The Cuillins, Skye, from Sligachan, Scotland
Page 87 Glen Trool, Scotland
Page 89 Muncaster Mill, Eskdale, Cumbria, England
Page 92 Borth, mid-Wales
Page 94 Arisaig, Inverness-shire, Scotland
Page 95 Cullen, Scotland
Page 97 Oban, Argyll, Scotland
Page 101 Aberystwyth, Wales
Page 114 Roche Abbey, South Yorkshire, England
Page 116 Windermere, Cumbria, England
Page 117 Froggatt Edge, Derbyshire, England
Page 118 Creswell Crags, North-East Derbyshire, England
Page 119 East Park, Hull, England
Page 122 Glasgow, Scotland
Page 128 Sheffield, England
Page 129 Top: Hong Kong
 Bottom: Paris
Page 134 Lochan na h'Achlaise, Rannoch Moor, Srathclyde, Scotland

AUTHORSHIP:
CHAPTERS 1, 2, 6, 8, 11 and 13 were written by John Hannavy
CHAPTERS 3, 4, 5, 7, 9, 10, and 12 were written by Duncan McEwan
Additional material and editing by David Kilpatrick